IMAGES
of Aviation

JOHN F. KENNEDY
INTERNATIONAL AIRPORT

IMAGES
of Aviation

JOHN F. KENNEDY
INTERNATIONAL AIRPORT

Joshua Stoff

ARCADIA
PUBLISHING

Published by Arcadia Publishing
Charleston SC, Chicago IL, Portsmouth NH, San Francisco CA

Printed in the United States of America

Library of Congress Catalog Control Number: 2008939825

For all general information contact Arcadia Publishing at:
Telephone 843-853-2070
Fax 843-853-0044
E-mail sales@arcadiapublishing.com
For customer service and orders:
Toll-Free 1-888-313-2665

Visit us on the Internet at www.arcadiapublishing.com

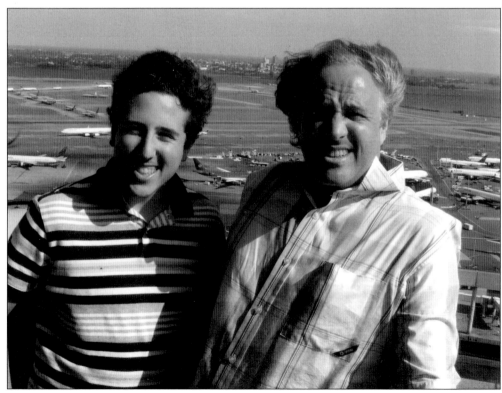

JFK TOWER CATWALK. Tyler Stoff (left) and Joshua Stoff are on the catwalk on the outside of the JFK tower in 2008. (Susan Rose.)

CONTENTS

ACKNOWLEDGMENTS

The author would like to thank the employees of the Port Authority of New York and New Jersey for their invaluable help in providing photographs for this work. Over the course of 50 years, they amassed a thoroughly wonderful archive that was lost in the attacks of September 11, 2001. The following individuals also provided much appreciated assistance: Paul Steidel (ex-Pan American employee), Henry Holden (noted writer), Susan Rose (air traffic controller), and Tyler Stoff for his documentary photography. Unless otherwise noted, all the photographs in this work come from the collection of the Cradle of Aviation Museum (CAM) in Garden City, New York, or the Port Authority of New York and New Jersey (PANYNJ).

INTRODUCTION

What is now known as John F. Kennedy International Airport came into being in the mid-1940s after the commercial failure of Floyd Bennett Field to the west in Brooklyn and after the stark realization that five-year-old LaGuardia Airport to the north was woefully inadequate to handle the volume of air traffic that New York City was going to experience. Thus the birth and steady growth of John F. Kennedy International Airport can clearly be seen as a microcosm of the explosive post–World War II growth of commercial aviation.

Pushed through by New York's air-minded mayor Fiorello LaGuardia, the airport sits 15 miles from midtown Manhattan in Jamaica Bay on the southeastern shore of Queens, Long Island, New York. Built in marshy tidelands on the site of the old Idlewild Golf Course, the huge new airport was known as New York International Airport–Idlewild Field at the time of its opening. With construction beginning in 1942, $60 million was originally spent on the 1,000-acre airport, which was built to handle up to 1,000 aircraft movements per day (an unimaginable amount at the time). In order to speed travel time between the new airport and Manhattan, a major new expressway, the Van Wyck, was cut through Queens to connect the airport directly to the Long Island Expressway and give easy Manhattan access via the Queens Midtown Tunnel. These new postwar airports also had to accommodate the growing number of foreign flag carriers and had to have the ability to replace passenger ship terminals as the principal gateway for visitors and immigrants to America.

The new airport in Queens was clearly a monument and legacy to New York's outgoing mayor LaGuardia, who more than any other person is responsible for the project. While under construction, it was proposed that the official name of the airport be Maj. Gen. Alexander Anderson Airport in honor of a New York World War I hero, which was actually voted on by the New York City Council. However, LaGuardia and his aides always referred to it as the Municipal Airport at Idlewild. To the press and public, however, in the airport's first decades, it was never called anything but Idlewild.

Due to its remarkable size and space allocated for terminals and support facilities, the new airport in Queens was markedly different than any other in the world at the time. The new commercial aircraft developed at the end of World War II had longer ranges and greater capacities, requiring larger airports with longer runways and bigger terminals. The smaller prewar airports were simply unable to meet the need. Thus the new airport divided the passenger volume for New York City with neighboring LaGuardia Airport. The latter covered traffic for the eastern half of the United States, while Idlewild accommodated long-distance operations, both trans-Atlantic and transcontinental. In the original plan, the new airport was also to have

12 runways arranged around the central terminal area like the vanes of a pinwheel, known as a tangential pattern. However, only seven of the spokes were ever built, which, due to terminal expansion, has now been reduced to two parallel pairs.

After opening in the summer of 1948, for the first 10 years of its existence, the airport consisted of a low-budget temporary terminal and a series of tin war surplus Quonset huts lined up in a row. A few scattered buildings served as cargo sheds and machine shops. From its inception, the airport's planners showed great foresight, leaving a huge elliptical area in the airport's center set aside for terminals, although it opened with temporary structures just so operations could begin. A major new construction program from the mid-1950s into the early 1960s saw the construction of new permanent hangars, terminals, cargo areas, and a control tower. The Port Authority of New York and New Jersey, which has operated the airport since its opening, constructed the central terminal, the International Arrivals Building, while the remainder of the terminals were left to individual airlines, resulting in a wide variety of styles, several of them noteworthy. By the mid-1960s, the airport was a model of how a major international airport should look and operate.

Through the 1950s and 1960s, Idlewild airport was America's only East Coast aerial gateway. Thus the eyes of the nation were focused upon it, as movie stars, rock stars, and foreign heads of state first arrived in America via its runways. Like a living creature, the airport steadily grew and evolved over time. Over the course of its first 15 years, the airport changed from a ramshackle series of makeshift buildings into a glamorous looking "city," with spectacular buildings full of an atmosphere of excitement and constant motion. Unlike its older brother to the north, LaGuardia Airport, John F. Kennedy International Airport has been under continuous construction (and reconstruction) since the day it opened. This situation is not expected to end in the foreseeable future.

Renamed John F. Kennedy International Airport in December 1963, it has now grown to cover 5,000 acres—one-third the size of Manhattan Island. Through the years, the central terminal area has expanded considerably with eight new terminals added between 1958 and 1971, resulting in the closure of three of the original seven runways and leaving two pairs of parallel strips. A new $11 billion redevelopment program, begun in the late 1980s, has seen the demolition of many old structures and the building of a huge, new central terminal, control tower, several spectacular new airline unit terminals, as well as a new roadway and efficient mass-transit system. Creating 200,000 jobs in the region, it is by far the busiest of New York City's three airports (including Newark Airport in New Jersey) and is the top international air passenger and airfreight gateway to America. Some 20 percent of all U.S. travelers who go overseas leave from here. It currently generates some $10 billion in wages and salaries and contributes $30 billion in economic activity to the New York City region. The airport now handles 50,000 international travelers every day and over 47 million passengers annually. One of the world's greatest airports by any definition, John F. Kennedy International Airport is now served by a remarkable 100 airlines from over 50 countries.

One

BEFORE JFK
1931–1944

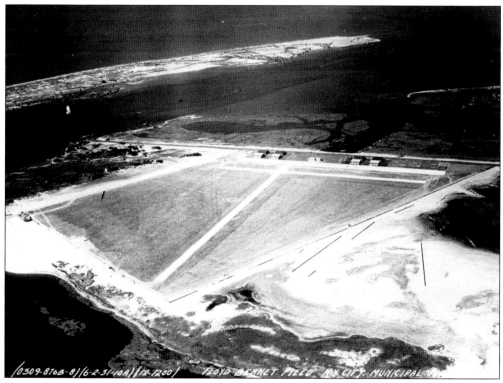

FLOYD BENNETT FIELD LOOKING SOUTHWEST, 1931. As the aviation industry boomed in America in the 1920s, the City of New York realized it needed a large, modern airport if it was to retain its status as one of the world's leading economic and financial centers. However, the site chosen for the new airport on the remote south shore of Brooklyn, without any direct rail or highway connections to Manhattan, was soon realized to be a mistake. (CAM.)

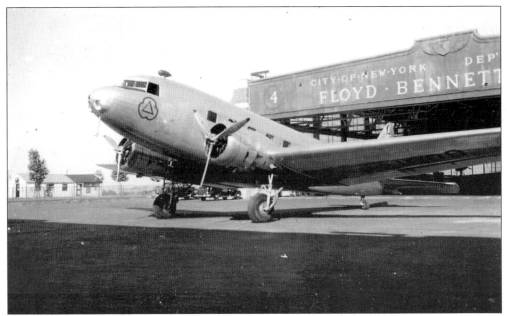

DC-2 AT FLOYD BENNETT FIELD, C. 1935. As Newark Airport in New Jersey was closer to Manhattan than Floyd Bennett Field, with a new highway connecting it to the city, it became New York's de facto commercial airport through the 1930s. Newark was awarded the lucrative New York airmail contract, and all the airlines serving New York operated from there. The sight of an airliner at Floyd Bennett Field was rare; this one is a Cities Service charter flight. (CAM.)

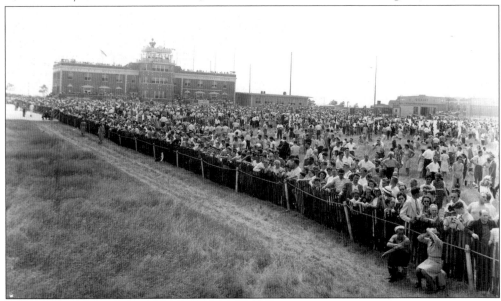

AIR SHOW AT FLOYD BENNETT FIELD, C. 1937. Although Floyd Bennett Field was built with the most modern and efficient airport amenities like this fine administration building, city leaders, and Mayor Fiorello LaGuardia in particular, worked tirelessly in the late 1930s to develop a large, new airport for New York. This time, they clearly took into account easy access to the city and the ability to serve many airlines and the throngs of passengers they knew would come. (CAM.)

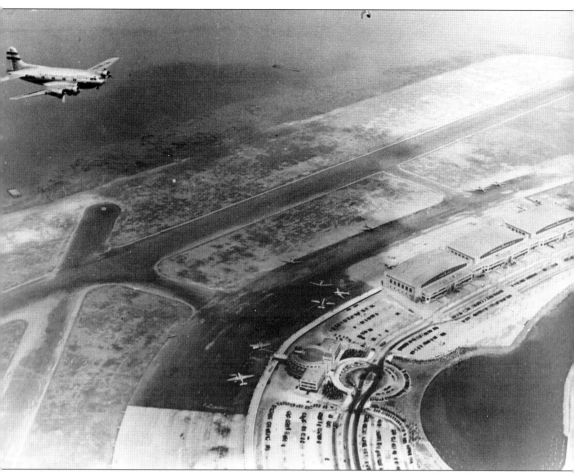

BOEING 307 OVER NEW YORK MUNICIPAL AIRPORT, 1940. Due to the commercial failure of Floyd Bennett Field, the mayor pushed through the construction of a huge, new airport, New York Municipal, on the site of the old, small Glenn Curtiss Airport at North Beach on the north shore of Queens, five miles from Manhattan. One of the largest Works Progress Administration (WPA) projects, heavy landfill created this 558-acre airport on Flushing Bay near a new main highway with unobstructed water approaches for flying boats. The boat basin on the right was for ferry service to Manhattan. (CAM.)

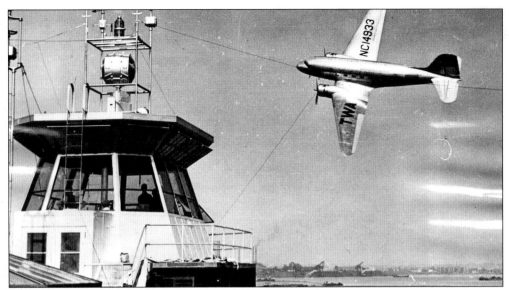

DC-3 OVER CONTROL TOWER, NEW YORK MUNICIPAL AIRPORT, 1940. Due to the fact that the new airport was largely pushed through by the persistence of Mayor Fiorello LaGuardia, the airport was soon given his name by the city council. Completed in 1939 under a $40 million WPA project, the new airport was wildly successful and was quickly given the New York airmail contract. Within weeks, all the airlines based at Newark Airport moved their operations to LaGuardia Airport. During this period, almost all the aircraft that serviced the airport were Douglas DC-3s, as seen here. (CAM.)

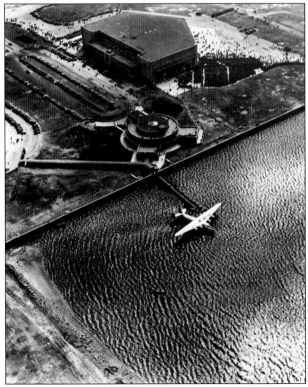

PAN AMERICAN CLIPPER AT THE MARINE AIR TERMINAL, LAGUARDIA AIRPORT, 1940. In the late 1930s and into the mid-1940s, the only aircraft capable of spanning the Atlantic Ocean were large, cumbersome flying boats. As these aircraft were very large for their day, they required large, smooth bodies of water in which to takeoff and land. Thus LaGuardia Airport was built on sheltered Flushing Bay for this purpose. Pan American Airways Boeing B-314 Clippers flew daily out of LaGuardia, using the field's spectacular art deco Marine Air terminal, the circular building at the foot of the dock. To this day, LaGuardia is the only American airport originally built to serve flying boats. (CAM.)

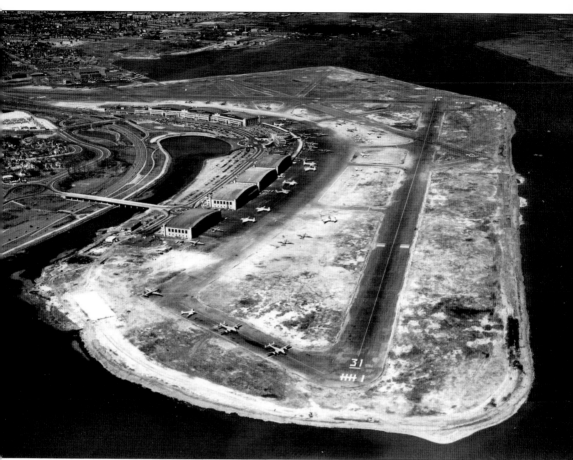

LaGuardia Airport Looking Northwest, 1948. Although its facilities and location were outstanding, it soon became clear that LaGuardia Airport was simply too small for the volume of air traffic it was beginning to experience. After World War II, commercial aviation boomed in America (as well as worldwide), and during the 1940s, LaGuardia was the busiest airport in the United States. It handled 197,000 flights in 1946 alone. As it was built on a small peninsula sticking out into Flushing Bay, there was simply no room for expansion. (PANYNJ.)

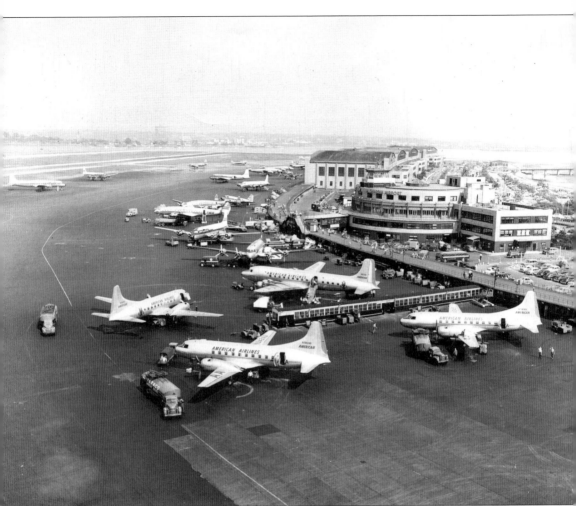

LaGuardia Airport Flightline, c. 1950. When it was built in 1939, LaGuardia was the most advanced airport in the world. It had the finest facilities, biggest hangars, and most advanced technology. Its 6,000-foot runways were the largest in the world at the time. Its central terminal, the structure seen at right center, set the standard for airport terminals for decades to come. It was the world's first airline terminal to feature separate levels for arriving and departing passengers in order to ensure the smooth flow of passengers and vehicles. (PANYNJ.)

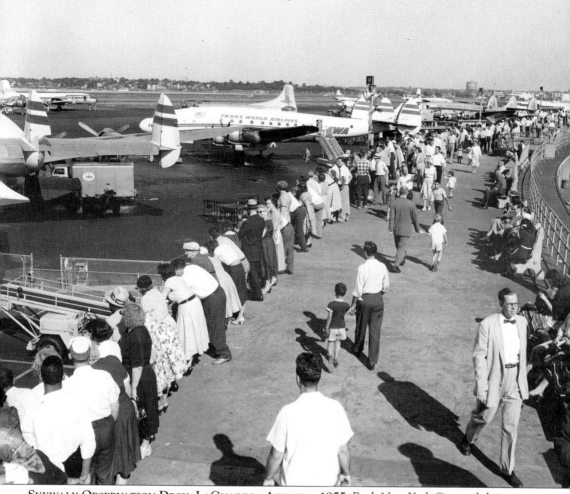

SKYWALK OBSERVATION DECK, LAGUARDIA AIRPORT, 1955. Both New York City and the port authority learned many lessons during the first years of LaGuardia Airport's operation. There was no question it was a commercial success; it was just too small to handle the ever-growing volume of air traffic and the larger, heavier airliners then being developed. Consolidating all the airlines serving the airport into one central terminal was a mistake, and it soon lead to gridlock. The Skywalk observation deck, seen here, on the roof of the terminal was wildly successful, however, as thousands of visitors showed up on nice days just to watch airliners takeoff and land. The port authority retained this feature in its next airport venture. (PANYNJ.)

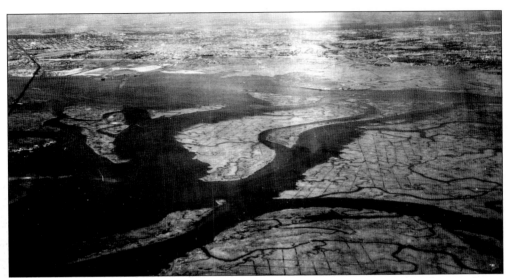

FUTURE SITE OF JOHN F. KENNEDY INTERNATIONAL AIRPORT, C. 1937. Carefully considering its options, the City of New York, again led by its aviation-minded mayor Fiorello LaGuardia, selected a marshy swampland on the south shore of Queens, bordering Jamaica Bay, as the site for its new commercial airport. It would have to be a huge landfill project, however, and a new highway would have to be built to speed travelers to Manhattan—an easy 15 miles away. Its main advantage was that the amount of space available for the new airport was vast, and most of the air traffic could approach and depart the airport over water, thus keeping the noise down in surrounding communities. (CAM.)

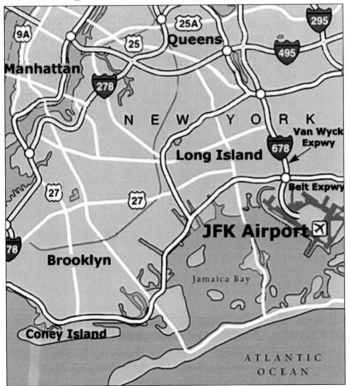

SITE OF JOHN F. KENNEDY INTERNATIONAL AIRPORT ON JAMAICA BAY. Jamaica Bay is basically a broad coastal lagoon that lies in the shadow of New York City skyscrapers. It is located on the southwestern tip of Long Island, equally in the boroughs of Brooklyn and Queens. Previously a rich fishing, shellfishing, and bird-hunting area, it consisted of many small islands dotted with baymen's cottages. Covering some 25,000 acres with an average depth of 12 feet, in the years before environmental awareness, the marsh proved to be cheap, available land for the development of a large golf course. (PANYNJ.)

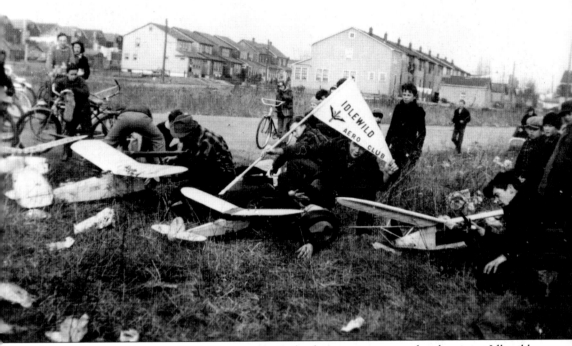

IDLEWILD AERO CLUB, C. 1938. The marshy site for the new airport was then known as Idlewild, named after a well-known golf course in the area. The wide-open marshes were also used as a flying area by early aircraft model builders, such as the Idlewild Aero Club, as they needed a great deal of open space in which to fly their free-flight gas engine model planes. The golf course and all of the surrounding land were purchased by the city, and although the course was soon gone, the area continued to be known simply as Idlewild. (CAM.)

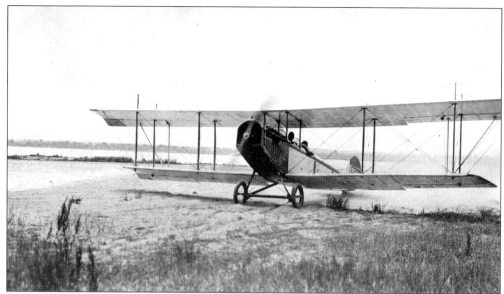

CURTISS JENNY AT JAMAICA SEA AIRPORT, QUEENS, C. 1927. John F. Kennedy International Airport (JFK) was not the first airport to open in the marshy Idlewild area of Queens. Jamaica Sea Airport (1927–1942) was located on a tiny spit of sand in Jamaica Bay. The crude airfield's primary function was operating sightseeing flights over Queens and Brooklyn and some primary flight instruction. (CAM.)

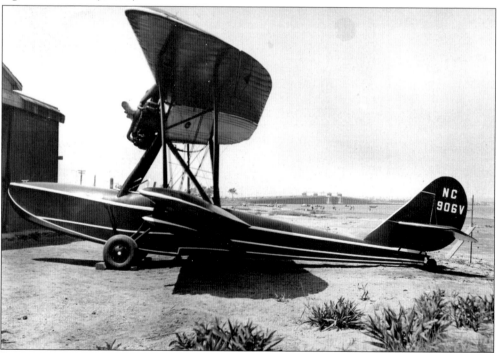

SAVOIA MARCHETTI S-56 AT JAMAICA SEA AIRPORT, C. 1939. This scruffy field, housing about eight aircraft, had three dirt runways between 1,500 and 3,000 feet long, one tin hangar, an office, and a wooden seaplane ramp on the bay. The site was purchased by the city and leveled for the construction of the huge, new commercial airport in 1942. (CAM.)

Two

FIRST YEARS
1945–1950

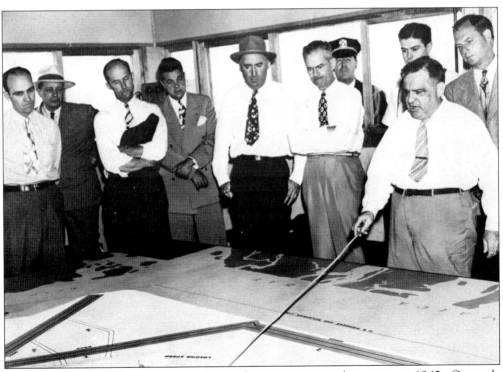

MAYOR EXPLAINS MODEL OF NEW YORK INTERNATIONAL AIRPORT, C. 1942. Correctly foreseeing the need for a huge, new airport, Mayor Fiorello LaGuardia (right) pushed through the construction of the new airport at Idlewild in the early 1940s. Designed to handle up to 360 operations per hour (compared with LaGuardia Airport's 42), the New York Board of Estimate approved the purchase of 1,200 acres for the airport on December 17, 1941. But 13 days later, the city took over the site and began grading and land filling operations. (PANYNJ.)

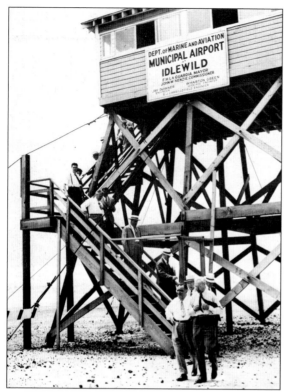

MAYOR LEADS TOUR OF AIRPORT SITE, C. 1942. As he was so proud of the massive new airport, Mayor Fiorello LaGuardia erected an observation tower in the center of the site from where dignitaries and guests could view the construction. Between 1942 and 1945, another 2,700 acres were purchased for the growing airport complex. At the time, it was estimated that the total cost for the new airport would be $200 million compared to $42 million for LaGuardia Airport (and $33 million for the Golden Gate Bridge). The original plan for the airport called for it having up to 12 runways in a tangential pattern. (PANYNJ.)

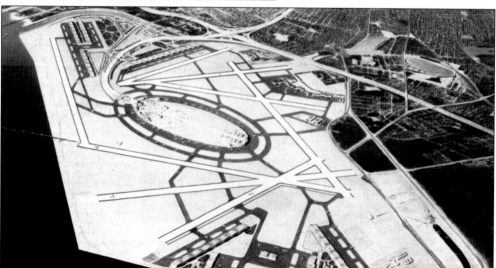

ARTIST'S RENDERING OF NEW YORK INTERNATIONAL AIRPORT, C. 1945. Done by noted artist Alexander Leydenfrost, this rendering shows an early concept for New York International Airport, with seven runways and widely scattered hangars. The one concept that was retained was a central area for terminals. In order to avoid the problem that Floyd Bennett Field faced—no highway leading to Manhattan—from the very outset, it was planned to build a new highway (seen at top center) to link up the new airport to the Long Island Expressway and Queens Midtown Tunnel. It was estimated that travelers could drive the 15 miles to Manhattan in 26 minutes. (PANYNJ.)

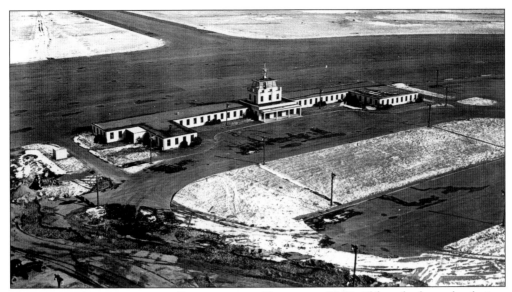

TEMPORARY ADMINISTRATION BUILDING AND TERMINAL, 1947. Although planned to have a 650-acre central "terminal city" area, it was clear that it would be many years before this would be built. Thus it was planned to have the new airport open with a single cinder block temporary terminal. At the time in 1947, the Port Authority of New York and New Jersey (PANYNJ) signed a lease to operate the airport for 50 years. Since renewed, it continues to operate the airport to this day. It was anticipated that by 1950, the airport would be handling up to 1,000 aircraft movements per day. (PANYNJ.)

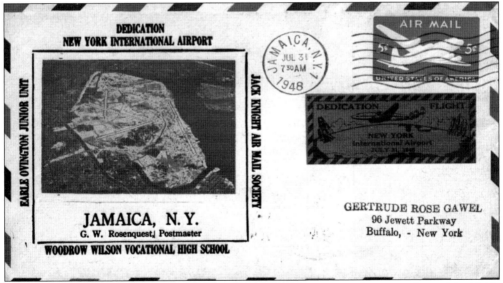

POSTAL COVER, DEDICATION OF NEW YORK INTERNATIONAL AIRPORT, JULY 31, 1948. Officially called New York International Airport at its dedication, the first official dedication flight in a Lockheed Constellation departed that morning carrying mail and passengers, arriving that afternoon in San Francisco. The force behind the airport, LaGuardia, passed away some six months before the airport's opening. During a speech just prior to his death, LaGuardia announced: "I'm taking this opportunity to announce to the whole world that we now have the best damn airport in the world." (CAM.)

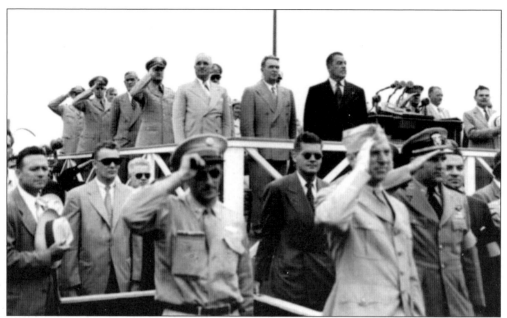

OPENING-DAY PODIUM, NEW YORK INTERNATIONAL AIRPORT, JULY 31, 1948. A crowd of over 200,000 attended opening-day festivities at the huge, new airport that featured a speech by Pres. Harry Truman (left of center). Over 500 newsmen covered the event that included many attractions on the ground as well as a huge air show. The armed services put on an air show that was one of the largest ever seen in America. (PANYNJ.)

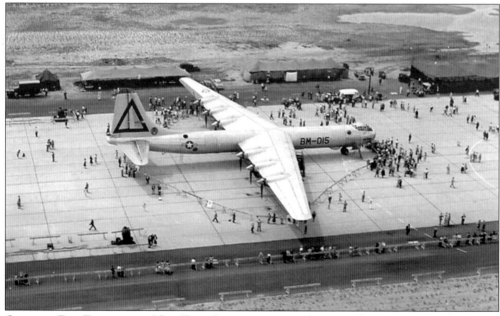

OPENING-DAY FLIGHTLINE, NEW YORK INTERNATIONAL AIRPORT, JULY 31, 1948. The newest commercial airliners were put on display, as well as a wide variety of military aircraft. Huge Convair B-36 bombers did a flyover, and from an English aircraft carrier came Hawker Sea Furys. Here visitors can be seen gawking at an enormous Convair B-36 bomber on exhibit. This was the last time the public was allowed on to the airport's flightline. (PANYNJ.)

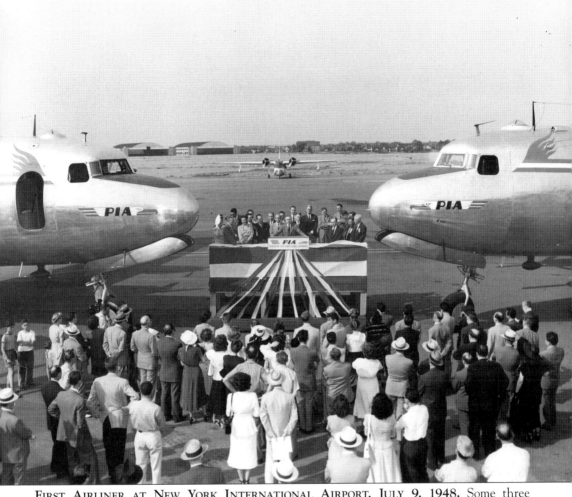

FIRST AIRLINER AT NEW YORK INTERNATIONAL AIRPORT, JULY 9, 1948. Some three weeks before the airport's official opening, the first scheduled airline flight arrived, a Peruvian International Airlines (PIA) Douglas DC-4 from Santiago, Chile. After appropriate speeches, this colorful platform was saved and used at the ceremony for the first outbound flight a week later. (CAM.)

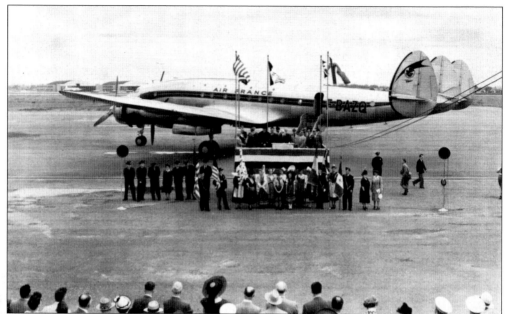

FIRST PASSENGER FLIGHT OUT OF NEW YORK INTERNATIONAL AIRPORT, JULY 14, 1948. Some two weeks before the airport's official opening, an Air France Lockheed Constellation departed the field for Paris. Taking place on Bastille Day, the event featured several speeches, media coverage, and an enthusiastic crowd. The flight to Paris was made in 14 hours, 15 minutes, including three stops for refueling. (PANYNJ.)

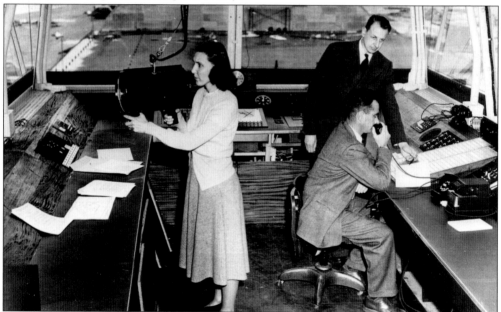

CONTROL TOWER INTERIOR, OPENING DAY, JULY 31, 1948. Atop the temporary terminal sat a temporary control tower. The standing controller is Christina Murray, and in the rear stands George McSherry, the airport's first manager. Murray is holding a light gun, which sends colored light signals to pilots the controllers are not in direct radio contact with. Red or green light flashes would tell them when to takeoff or land. (PANYNJ.)

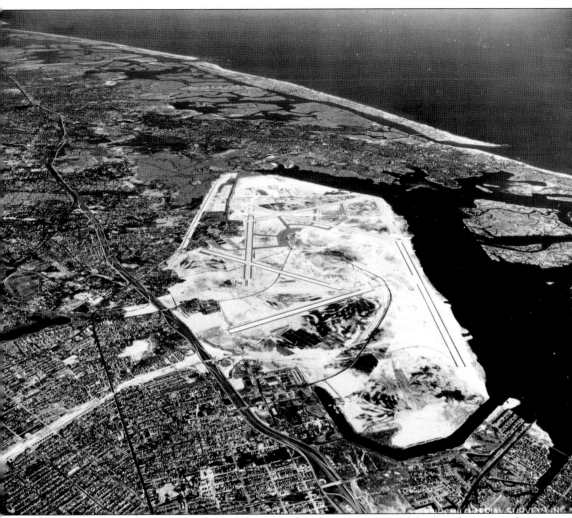

NEW YORK INTERNATIONAL AIRPORT LOOKING SOUTHEAST, 1948. The broad expanse the airport covered, as well as the fact that it was largely built on sand, is evident in this photograph. The south shore of Long Island runs across the photograph, and to the left of the airport is the belt parkway. The new highway, the Van Wyck Expressway, built just to link the airport to Manhattan via the Long Island Expressway, is under construction to the left. The Van Wyck Expressway opened in early 1950. In the late 1990s, an elevated rail line was finally built down the median of the highway to link the airport to the Long Island Railroad and the New York City subway system. (PANYNJ.)

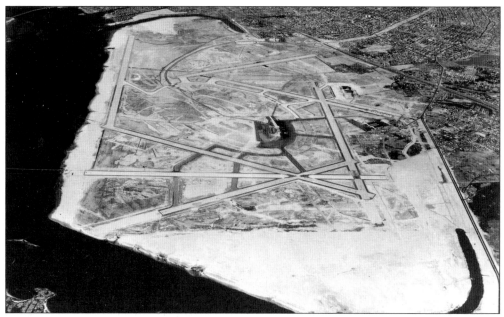

NEW YORK INTERNATIONAL AIRPORT LOOKING NORTHWEST, 1949. The airport's original seven runways can be seen along with the tiny central terminal area. The original runways were 200 feet wide and between 7,500 and 9,300 feet long. With the opening of the new airport in 1948, all transcontinental and transatlantic flights shifted here from LaGuardia Airport, which was left to serve flights from within an approximately 1,500-mile range. New York International Airport was the world's first large-scale international airport. (PANYNJ.)

PASSENGER TERMINAL, NEW YORK INTERNATIONAL AIRPORT, 1948. This view is of the field side of the quaint, temporary terminal. The cinder block terminal was built at a cost of $125,000, and drawing on the LaGuardia Airport experience, it included a rooftop promenade. During the airport's first year of operation, there were 18,115 aircraft movements serving 222,620 passengers. (PANYNJ.)

DOUGLAS DC-6 INBOUND TO NEW YORK INTERNATIONAL AIRPORT, C. 1948. In the late 1940s and early 1950s, the most common aircraft at the new airport were Douglas DC-6s. The DC-6 was a piston-powered airliner in production by Douglas between 1946 and 1959. Basically it was a stretched and greatly improved version of the DC-4, designed to compete with the successful Lockheed Constellation in the long-range transport market. (CAM.)

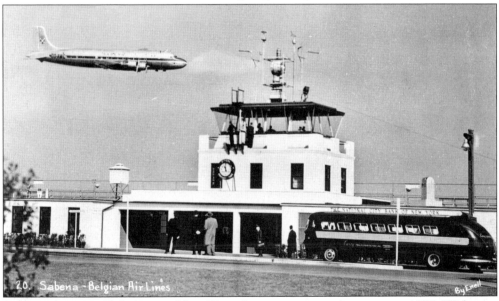

SABENA AIRLINES DC-6 OVER NEW YORK INTERNATIONAL AIRPORT, C. 1950. With over 700 built, DC-6s were common sights at American airports in the 1950s and especially the new airport at Idlewild. The DC-6 is regarded by many to be the ultimate piston-engine airliner from the standpoint of ruggedness, reliability, economical operation, and handling qualities. It had a range of 3,000 miles, cruising at 315 miles per hour. Sabena is the national airline of Belgium. (CAM.)

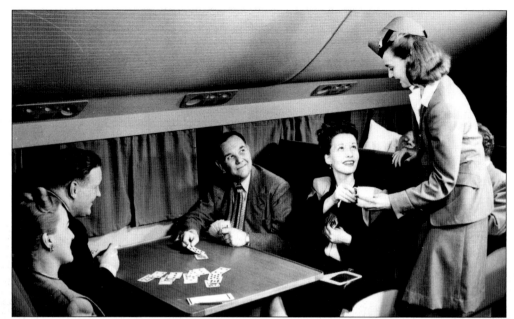

UNITED AIRLINES DC-6 INTERIOR, C. 1952. In the 1940s and the 1950s, there was basically only one class of airline service—first, and only the wealthy could afford to fly. Pan American Airways first introduced tourist-class service on transatlantic flights on DC-6s, operating out of New York in 1952. The DC-6 could carry up to 102 passengers in comparative luxury for its day. (CAM.)

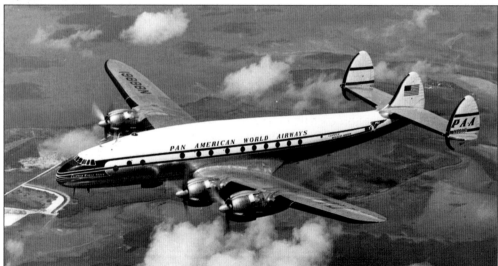

PAN AMERICAN AIRWAYS LOCKHEED CONSTELLATION, C. 1950. The most attractive airliner to serve New York International Airport, indeed one of the most appealing of its day, was the Lockheed Constellation. In production between 1943 and 1958, the "Connie" was a four engine propeller-driven airliner with a distinctive triple tail and a graceful dolphin-shaped fuselage. As the first pressurized airliner in widespread use, it helped to usher in affordable and comfortable air travel for the masses. Upon New York International Airport's opening in 1948, all transcontinental and transatlantic air traffic involving Constellations moved over from LaGuardia Airport. (CAM.)

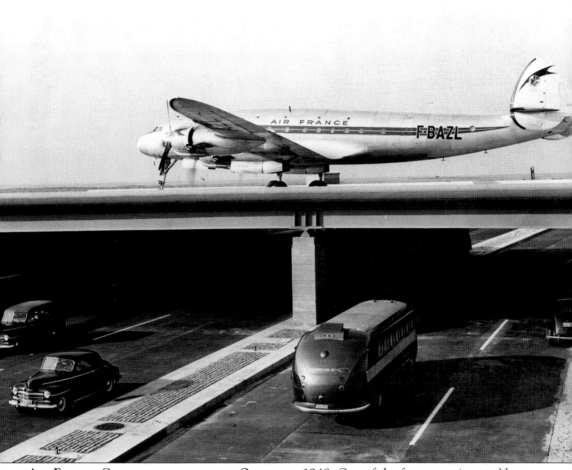

AIR FRANCE CONSTELLATION ON THE OVERPASS, 1948. One of the features unique to New York International Airport was the impressive overpass that connected the runways across the main road to the terminal area. Since reinforced to handle huge jets, the overpass is still in daily use. The Constellation carried between 62 and 95 passengers depending on configuration. They cruised at 350 miles per hour, with a range of 4,400 miles. (PANYNJ.)

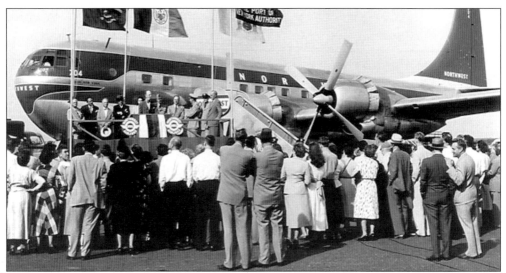

NORTHWEST AIRLINES BOEING STRATOCRUISER, 1950. Probably the most glamorous airliner to serve New York International Airport in its earliest years was the Boeing B-377 Stratocruiser. Extremely complex and expensive, the Stratocruiser was one of the great postwar propeller-driven airliners, although only 56 were built. The B-377 was the flagship of both Pan American Airways and British Overseas Airways Corporation (BOAC) from their delivery in 1949 until jets phased them out in 1959. They primarily serviced transatlantic flights from New York to various points in Europe. This occasion marks the first flight of a Northwest Airlines airplane from New York to Tokyo via Seattle in 1950. (PANYNJ.)

BOEING STRATOCRUISER ON THE RAMP, NEW YORK INTERNATIONAL AIRPORT, 1951. Too heavy for the runways at nearby LaGuardia Airport, all transatlantic and transcontinental Stratocruiser flights used the new airport at Idlewild. The spiral staircase on the Stratocruiser that led to a lower-deck lounge inspired a similar staircase on the later Boeing 747. Note the passenger's short walk across the tarmac to board the aircraft. In the years before jetways, this could be an unpleasant experience in inclement weather. (CAM.)

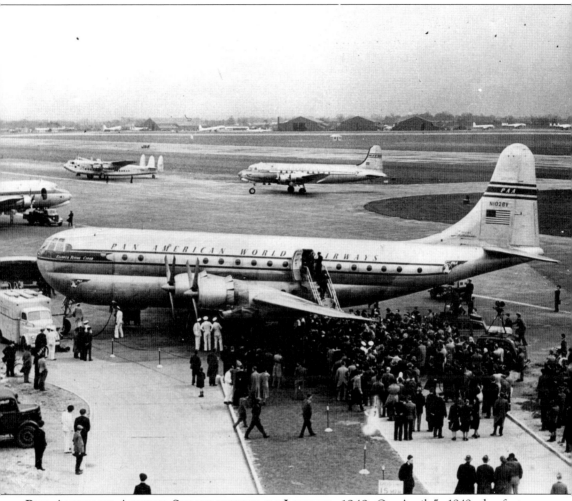

PAN AMERICAN AIRWAYS STRATOCRUISER IN LONDON, 1949. On April 5, 1949, the first Pan American Airways Stratocruiser flight from New York International Airport to London's Heathrow Airport took place. The event drew a large crowd and media coverage, as this was the largest commercial airliner in the world at the time. Stratocruisers carried between 60 and 100 passengers, depending on configuration, and they cruised at 301 miles per hour, with a range of 3,600 miles. (CAM.)

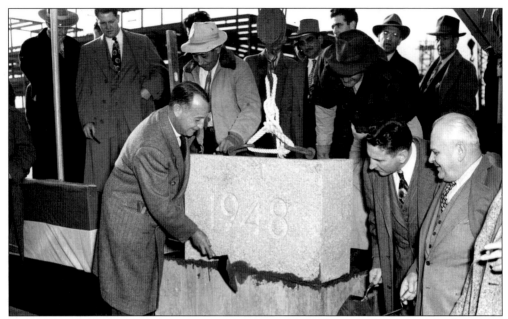

LAYING THE CORNERSTONE OF THE FEDERAL BUILDING, NOVEMBER 8, 1948. The first major permanent building at New York International Airport was the federal building located on the northwest corner of the field. Here port authority chairman Howard Cullman applies the mortar, while Delos Rentzel, administrator of the Civil Aeronautics Authority (now the Federal Aviation Administration), looks on. (PANYNJ.)

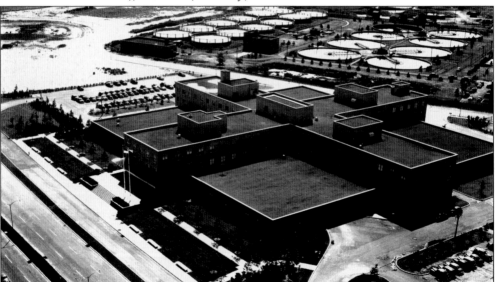

FEDERAL BUILDING AT NEW YORK INTERNATIONAL AIRPORT, 1951. Although unimpressive in design, the federal building was at least the first structure on the field to have an air of permanence about it. In the rear is the field's sewage treatment plant, while bare patches of sand, which covered most of the field, can be seen in the distance. This building largely housed Federal Aviation Administration personnel who supervised operations at the airport and those in the greater New York area. The building still stands but is no longer used by the Federal Aviation Administration. (PANYNJ.)

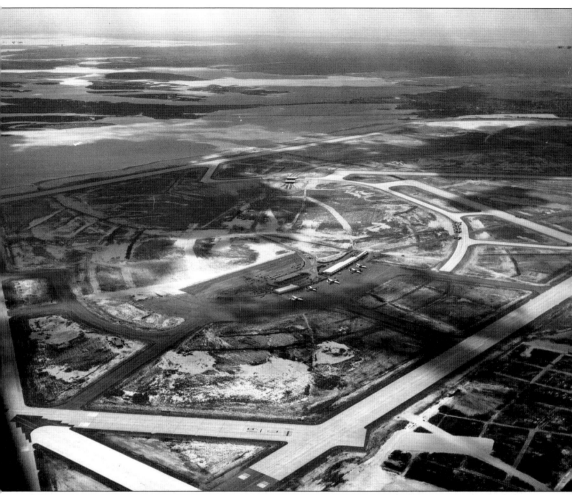

New York International Airport Looking West, 1949. Until the construction of the International Arrivals Building in 1957, the temporary central terminal, pictured in the center of the photograph, was the sole terminal on this huge, windswept field. Through the 1950s, another 4,000 acres were allocated to the airport. In the field's first full year of operation (1949), there were 18,115 aircraft movements. (PANYNJ.)

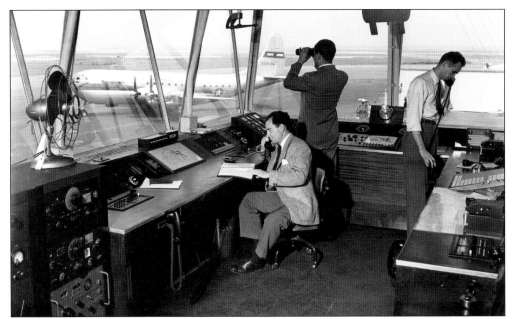

CONTROL TOWER INTERIOR, 1949. This, the first control tower at New York International Airport, was located atop the temporary terminal. It remained in operation for less than five years, being replaced by the second tower on the field in 1952. In the rear can be seen a U.S. Air Force Boeing Stratocruiser. Note the light gun still hanging from the ceiling and the apparent lack of air-conditioning. (PANYNJ.)

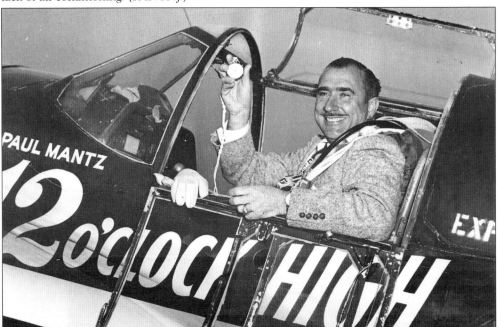

FIRST SPEED RECORD AT NEW YORK INTERNATIONAL AIRPORT, JANUARY 21, 1950. In January 1950, famed aviator Paul Mantz set a new transcontinental speed record for piston-driven airplanes. He flew from California to New York in four hours and 53 minutes in a highly modified P-51D Mustang *12 O'Clock High*. (CAM.)

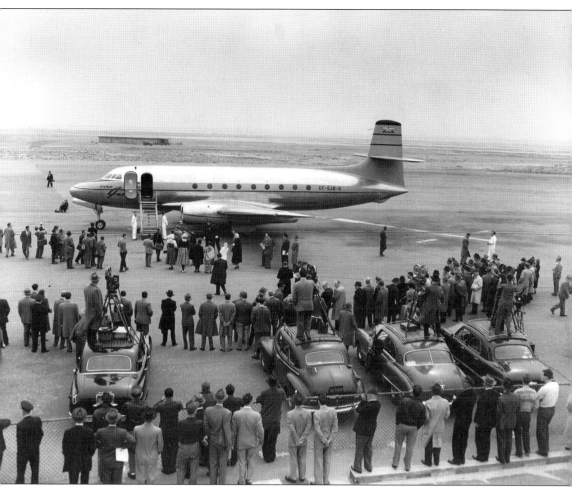

FIRST JET-ENGINE PASSENGER AIRCRAFT TO ARRIVE IN AMERICA, APRIL 18, 1950. In April 1950, New York International Airport witnessed the arrival of the first jet airliner in the United States. The experimental Avro Jetliner made a test flight from Toronto, where it was built, to New York, arousing much interest in the United States, and it was one of the outstanding aeronautical achievements of its day. First flown in August 1949, the Jetliner was the first passenger jet to fly in North America. However, due to its high cost and low payload, no airlines ordered it, and only one was built. The name Jetliner stuck, however, and has since been applied loosely to every jet passenger plane that flies. (PANYNJ.)

FEDERAL INSPECTION FACILITY, NEW YORK INTERNATIONAL AIRPORT, 1948. One end of the temporary terminal housed the customs area where all incoming passengers from overseas were screened. Crammed into this one terminal were also all the airline ticket counters, gates, several small stores, a bank, and a coffee shop. It remained this way for the first 10 years of the airport's existence. (PANYNJ.)

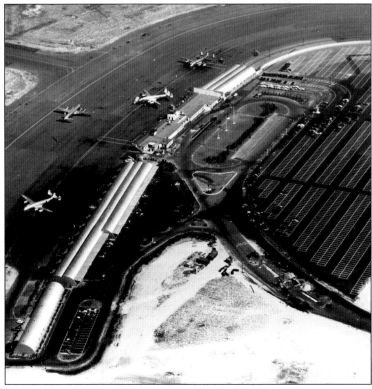

NEW YORK INTERNATIONAL AIRPORT, AERIAL VIEW, 1949. The temporary terminal was quickly given war surplus military Quonset huts on its wings to handle the steadily surging passenger volume. On the ramp sit three Lockheed Constellations and two Douglas DC-6s. Note the lightly used parking lot—a stark contrast to today's JFK airport. (PANYNJ.)

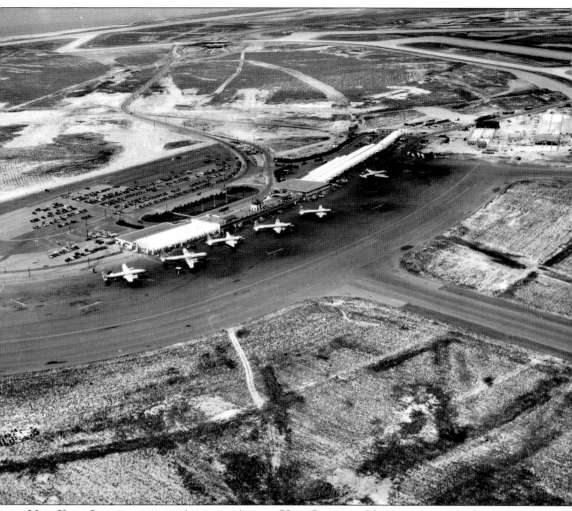

NEW YORK INTERNATIONAL AIRPORT, AERIAL VIEW LOOKING NORTHWEST, 1950. Passenger traffic is clearly increasing, and the first specialized airfreight building is now taking shape to the right. At the top of the photograph can be seen the aircraft overpass with the single access road going underneath it. From left to right on the ramp are a Lockheed Constellation, a Boeing Stratocruiser, and four Douglas DC-6s. (PANYNJ.)

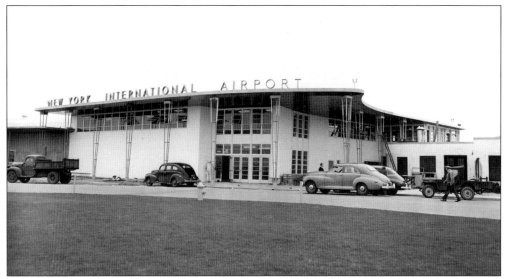

TERMINAL EXPANSION, 1950. In the spring of 1950, the first expansion was made to the saturated central terminal. A new two-story addition was added to one end of the terminal, housing new waiting areas, shops, and additional airline counter space. The open windows reveal that this structure, like all others at the airport, was still not air-conditioned. (PANYNJ.)

FIRST HANGARS AT NEW YORK INTERNATIONAL AIRPORT, 1950. Built by the port authority, in 1950, the first aircraft hangars opened on the north side of the field. The eight hangars, measuring 218-by-330 feet, were the largest triple-hinged, steel-arch-type hangars in the world. Hangars one, three, and five, seen here, were leased by Pan American Airways and used for heavy aircraft maintenance. From the 1950s through the 1970s, New York International Airport was Pan American Airways's major maintenance center. In the early 1950s, United Airlines, Eastern Air Lines, American Airlines, and Trans World Airlines (TWA) also built hangars for their own use on the north side of the field. (PANYNJ.)

Three

TAKING OFF
1951–1960

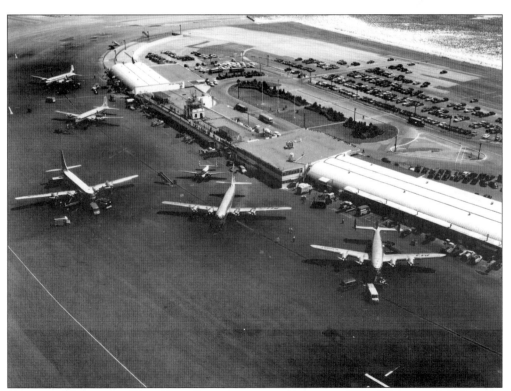

CENTRAL TERMINAL, NEW YORK INTERNATIONAL AIRPORT, 1951. The extended Quonset huts and two-story addition are clearly evident in this photograph. On the ramp are a Lockheed Constellation, two Boeing Stratocruisers, and two DC-6s. Although officially called New York International Airport, it was commonly referred to as Idlewild through the 1950s. In fact, its abbreviation on all official business and baggage tags into the early 1960s was IDL. (PANYNJ.)

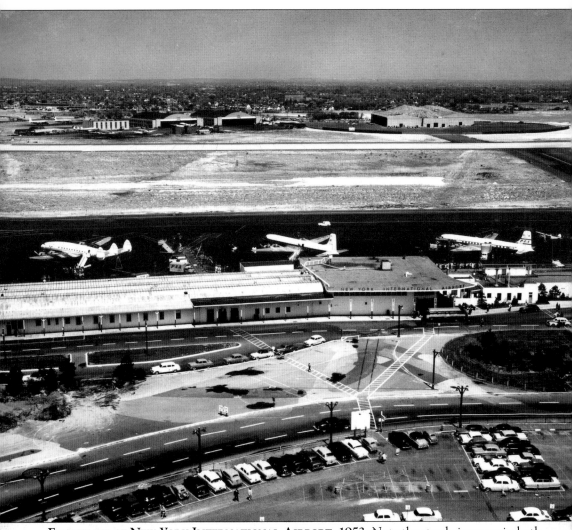

FLIGHTLINE OF NEW YORK INTERNATIONAL AIRPORT, 1953. Note the steady increase in both automobile traffic and aircraft on the ramp through the 1950s. The three types of aircraft on the ramp are DC-6s, Lockheed Constellations, and Boeing Stratocruisers. The airport's fuel tank farm can be seen at the far edge of the field. The distance passengers walked across the ramp from the terminal to the aircraft could be unpleasant in inclement weather not to mention the noise and ramp traffic. (PANYNJ.)

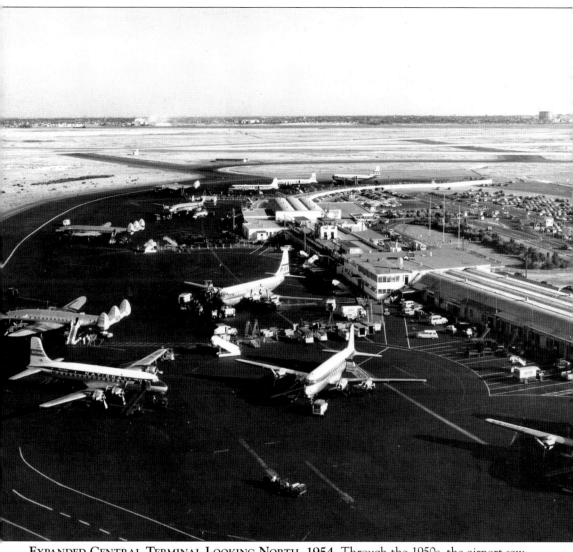

EXPANDED CENTRAL TERMINAL LOOKING NORTH, 1954. Through the 1950s, the airport saw a steady stream of new construction and growth. The north side of the field was being cluttered with a hodgepodge of new maintenance and airfreight hangars. Several of these buildings are still in use. Next to the DC-6 on the right appears to be a parked Piper Cub. (PANYNJ.)

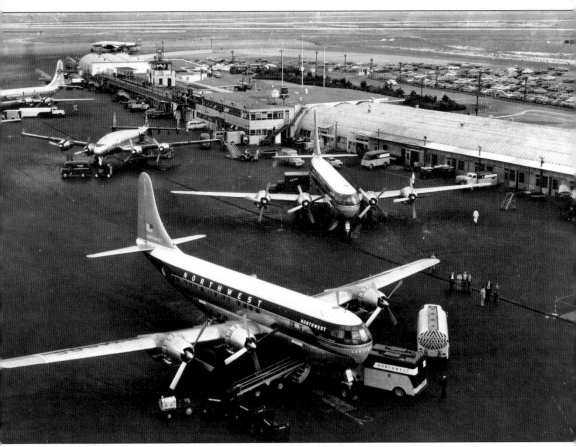

FLIGHTLINE, C. 1953. Front and center sit two Northwest Airlines Boeing Stratocruisers. Northwest Airlines was founded in the Midwest in 1926 and was headquartered in Minneapolis. It was among the first purchasers of Stratocruisers and used them on routes extending from New York to the Far East. It was the world's sixth-largest airline. Passengers exited the Quonset huts on the right to get to their aircraft. (PANYNJ.)

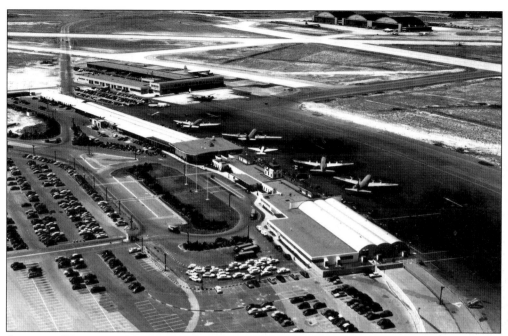

CENTRAL TERMINAL LOOKING NORTHWEST, C. 1952. New to the scene is the first cargo operations building just beyond the terminal. Hangars one, three, and five can be seen at the upper right of the photograph. The crowded taxi line is of note; clearly far more people were beginning to fly. Parked in the center of the flightline is a Beech 18, probably for corporate use. (PANYNJ.)

SLICK AIRWAYS C-46S, 1953. One of the first airfreight operators to work out of New York International Airport was Slick Airways, founded by Earl Slick in 1946. Using 10 war surplus Curtiss C-46s, Slick was the first American exclusively airfreight carrier. In the early 1950s, it was the largest all-cargo commercial operator in the country; however, increasing competition ultimately forced them out of business in 1966. (PANYNJ.)

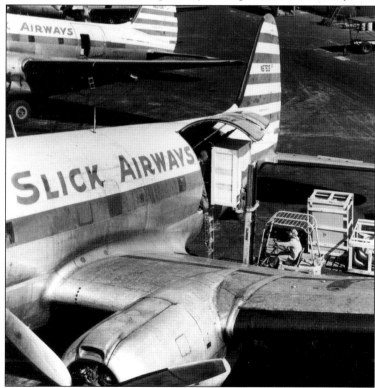

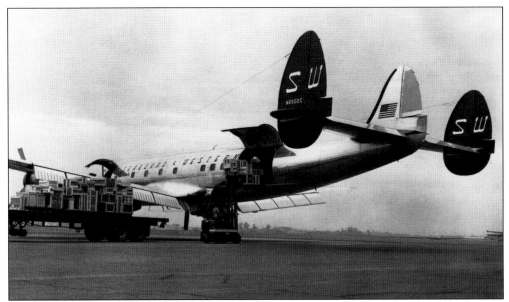

SEABOARD AND WESTERN AIRLINES LOCKHEED CONSTELLATION ON THE RAMP, C. 1958.
Another major all-cargo airline operating out of New York International Airport was Seaboard and Western Airlines, founded in 1946. Starting with Curtiss C-46s, it later operated freighter versions of the Constellation and CL-44s in the 1960s. It then moved on to DC-8 freighters and ultimately Boeing 747s. In 1961, it became Seaboard World Airlines and ultimately merged with Flying Tigers in 1980. (Seaboard World Airlines.)

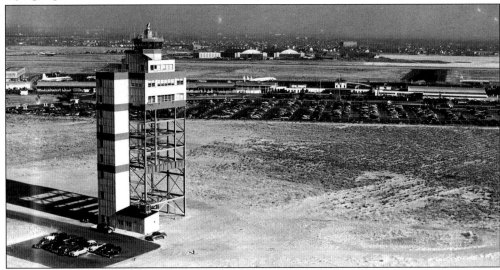

NEW YORK INTERNATIONAL AIRPORT LOOKING NORTH, 1952. By the mid-1950s, the explosive growth in air travel forced the port authority to finally come up with a plan for the development of the airport. In March 1955, a master plan was unveiled, and construction finally began. The first "permanent" building constructed in the central terminal city area was a new 11-story control tower, which ultimately sat at the entrance to a huge, new central terminal. The tower originally opened in 1952 as a skeletal steel structure that was encased in glass in 1957. In this view, the old central terminal, with the original control tower on top, can be seen in the distance. (PANYNJ.)

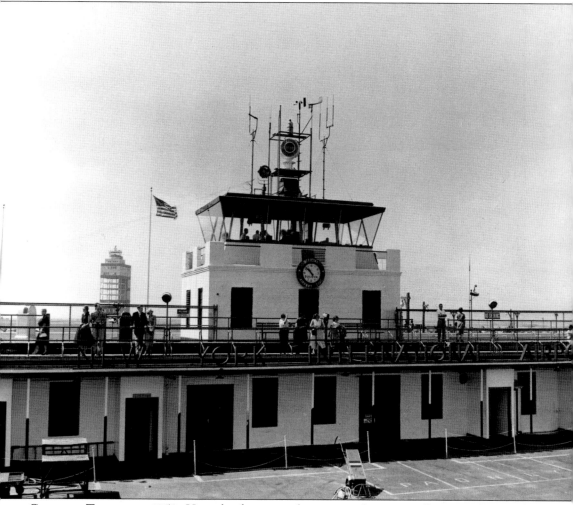

CENTRAL TERMINAL, 1952. Here the first control tower can be seen, still in use, on top of the old terminal, with the new control tower under construction in the rear. Visitors stroll on the promenade while the Bulova Clock shows the official airport time. All signage on the field always stated "New York International," as Idlewild was an unofficial name. (PANYNJ.)

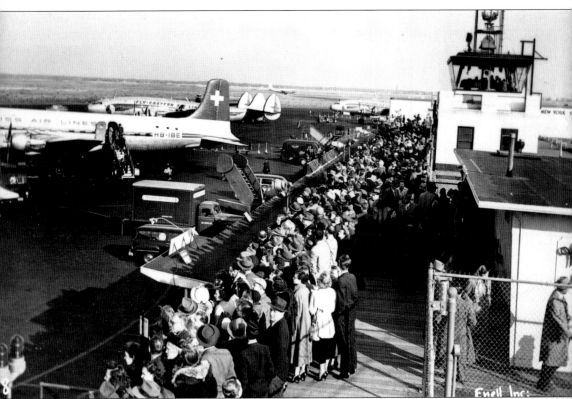

SKYWALK AT NEW YORK INTERNATIONAL AIRPORT, C. 1952. The one wildly successful feature at LaGuardia Airport that was adopted from the beginning at New York International Airport was a rooftop promenade on the central terminal. On pleasant weekend afternoons, thousands of visitors descended on the airport just to watch the excitement of huge airliners taking off and landing. Visitors could also wave down to arriving friends and relatives. When the new International Arrivals Building was planned in the mid-1950s, the architects made certain to retain this popular feature. (CAM.)

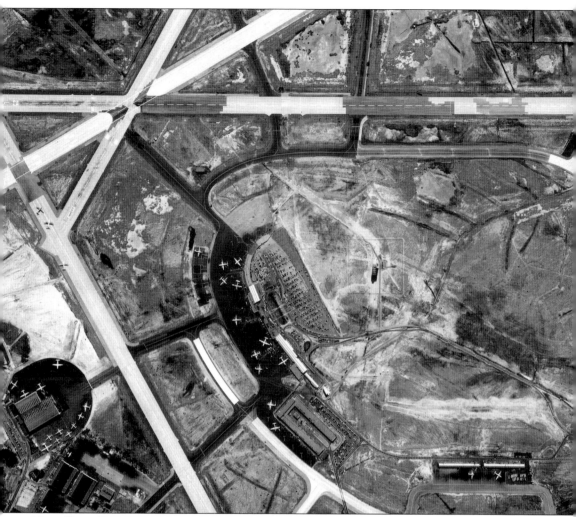

NEW YORK INTERNATIONAL AIRPORT, AERIAL VIEW, 1954. Taken from directly overhead, this view shows the central terminal with the runways set out around it. In the lower left are the maintenance hangars with the airfreight building in the lower center. Clearly the parking lots are jammed in this photograph, and the ramp and outlying buildings are crowded with aircraft. Aircraft movements rocketed to 149,825 in 1956, and the passenger count jumped to 4,490,050. (CAM.)

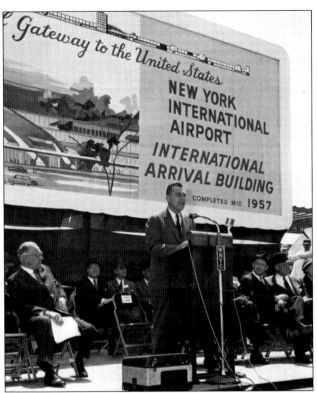

CONSTRUCTION OF THE INTERNATIONAL ARRIVALS BUILDING, 1956. The master plan for the redeveloped airport included a central terminal city—a magnificent mile-long oval of new passenger terminals. The 660-acre core would be served by an elaborate 10-mile internal roadway system. The terminal areas would be extensively landscaped with reflecting pools and fountains and parking for 6,000 automobiles. The most prominent structure would be the 11-block-long International Arrivals Building with its attached airline wing buildings, which would serve all foreign-flag airlines and passengers requiring customs clearance. Here Gov. Robert Meyner of New Jersey gives an update on construction at a press conference. (PANYNJ.)

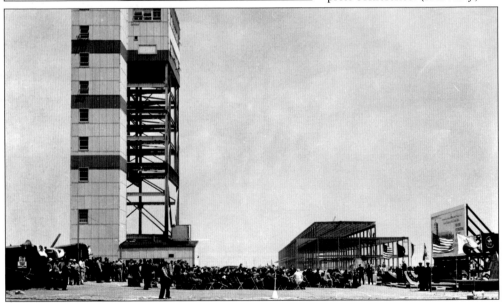

LAYING THE CORNERSTONE, INTERNATIONAL ARRIVALS BUILDING, APRIL 30, 1956. On the left stands the still-skeletal new control tower, while the International Arrivals Building and airline wings take shape on the right. The arched entrance of the International Arrivals Building, with its adjoining tower, marked the entrance to the "Aerial Gateway to the United States." The International Arrivals Building was designed by Skidmore, Owings and Merrill, who had last designed the U.S. Air Force Academy. (PANYNJ.)

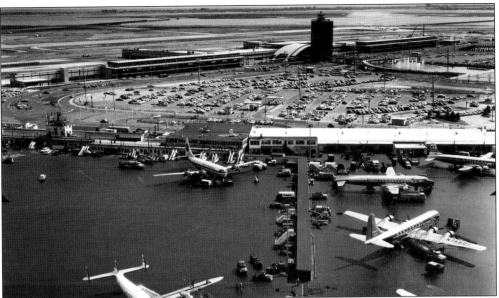

NEW YORK INTERNATIONAL AIRPORT LOOKING SOUTH, 1958. For a brief period, both the old and new terminals operated simultaneously. In left center sits the temporary terminal and control tower with its Quonset huts off to the right. In the distance can be seen the International Arrivals Building, east and west airline wings, and the new control tower. The parking lot is already jammed. Still the pre-jet age, the airliners are a combination of Boeing Stratocruisers, Lockheed Constellations, and DC-6s. (PANYNJ.)

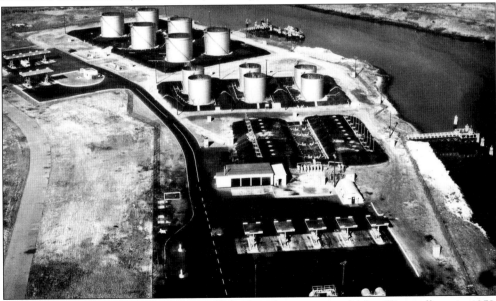

FUEL STORAGE FACILITY, 1957. Originally built with a capacity of 4.8 million gallons, in 1958, the fuel tank farm was increased to 7 million gallons due to the greatly increased amount of air traffic requiring fuel. At the time, over 13 million gallons of fuel a month were delivered to aircraft. The fuel tank farm was and still is located on a channel on the west side of the field where it is serviced by small tankers and fuel barges. Since this time, it has more than doubled in capacity yet again. (CAM.)

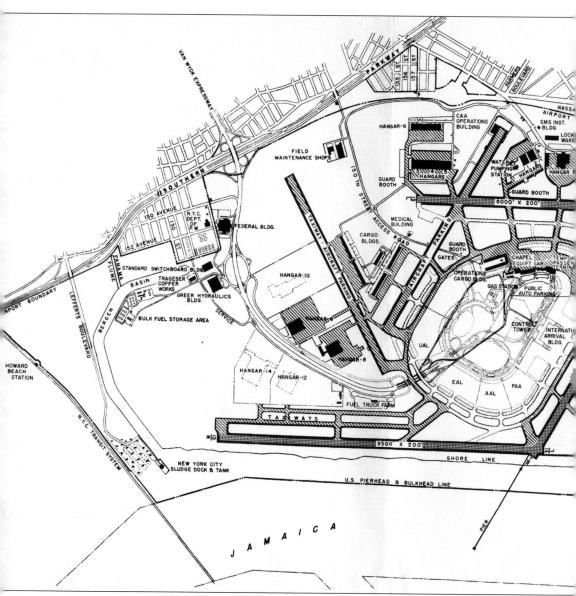

PLAN OF NEW YORK INTERNATIONAL AIRPORT, 1956. The plan ultimately chosen by the port authority featured a 660-acre core terminal city. Space was allocated in this ring for the International Arrivals Building as well as separate unit terminals for the major airlines serving the field, including TWA, United Airlines, Eastern Air Lines, American Airlines, and Pan

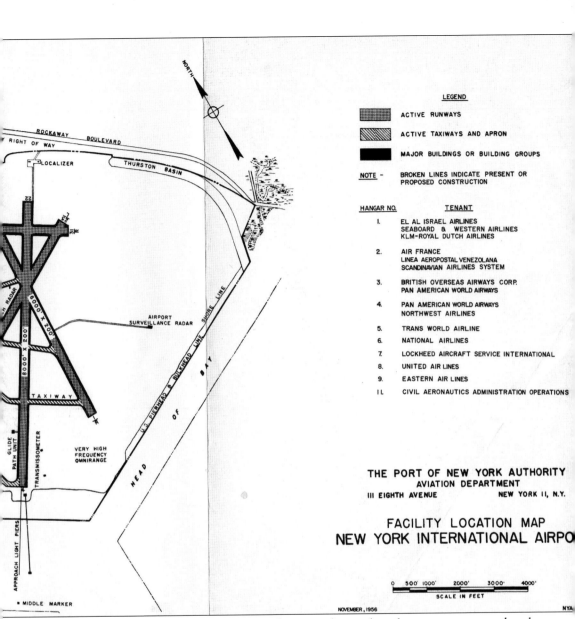

American Airways. Due to the expanded core, however, the number of runways was now reduced to five, with freight and maintenance areas still on the west and north sides of the field. Jamaica Bay surrounds the field on all but the north side, which is bounded by the Belt Parkway. This is the same general plan the field retains today. (CAM.)

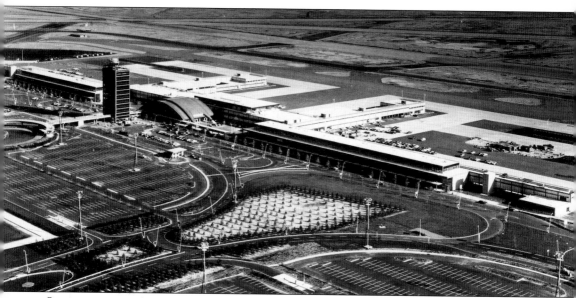

INTERNATIONAL ARRIVALS BUILDING AND AIRLINE WINGS, 1957. Taken just prior to opening, this view shows the layout with the arched International Arrivals Building and tower in the center and the east and west airline wings spread off to the sides. Built at a cost of $30 million, the 590,000-square-foot building housed customs and inspection services, restaurants, shops, waiting areas, offices, ticket counters, and space for 14 foreign airlines. Four arcades provided 24 aircraft gates, and a 2,000-foot-long open observation platform extended the full length of the building. (PANYNJ.)

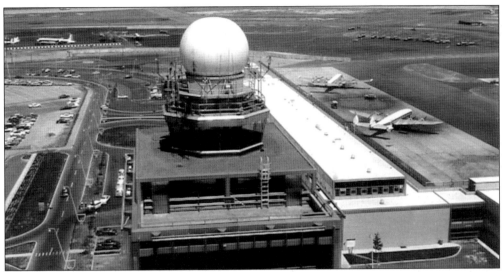

CONTROL TOWER CAB, NEW YORK INTERNATIONAL AIRPORT, C. 1958. While construction was underway on the International Arrivals Building, the control tower that had been skeletal since its construction in 1952 was finally encased in glass and steel with interior office and work spaces added. It was also given a state-of-the-art radar system, as evidenced by the white radome now on top of the tower. The terminal city concept was conceived and planned by the Port of New York Authority's Aviation Planning Division under the direction of Thomas Sullivan. This photograph was taken just prior to the jet era, as can be seen by the two Lockheed Constellations on the ramp. (PANYNJ.)

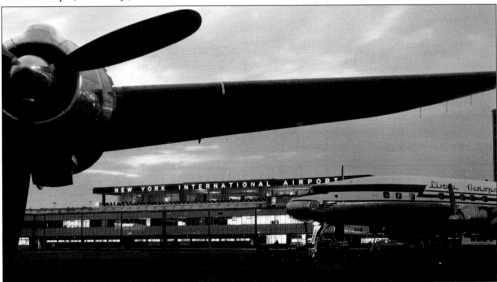

INTERNATIONAL ARRIVALS BUILDING FROM THE FLIGHTLINE, 1958. The International Arrivals Building was the dominant structure in terminal city, and it symbolized the airport's international character. This building handled all international air travelers entering the United States through the port of New York and thus was the country's air-age front door. It was three stories high and 640 feet deep, with two airline wing buildings giving it an overall length of 2,300 feet, or 11 city blocks. Although not an architectural masterpiece like the first buildings at LaGuardia Airport, the design was simple and functional. (PANYNJ.)

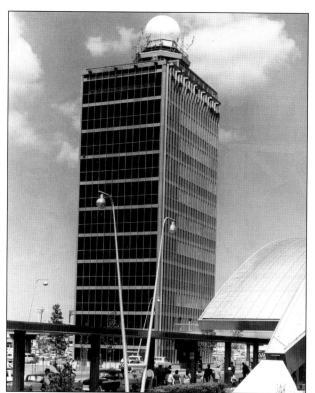

CONTROL TOWER AND ENTRANCE TO THE INTERNATIONAL ARRIVALS BUILDING, 1958. Of the $150 million spent on the 1950s redevelopment of the airport, $30 million was spent on the construction of the International Arrivals Building. A specially designed lighting system was installed to cover the entire terminal city area with a blanket of never-ending daylight. Designed by General Electric, a new lamp was developed with a floodlight rated at 81,000 lumens, using a 1,500-watt mercury charge as a light source. The lamps were housed in 54-pound metal fixtures that were 22 inches in diameter. They were usually mounted in pairs, as seen here, on 75-foot-long steel standards. (PANYNJ.)

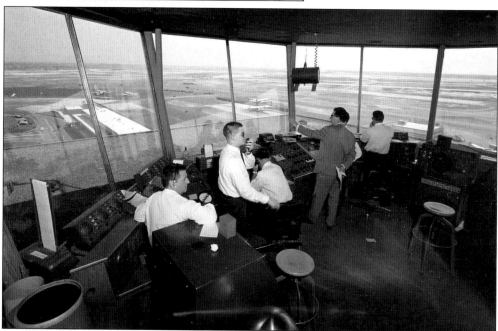

INTERIOR OF THE NEW CONTROL TOWER, 1959. A much larger, more efficient design with the most modern equipment, this second control tower remained in operation for 40 years. Still the pre-jet era, only propeller-driven aircraft are visible on the field. One holdover from the original tower was the same light gun, still hanging from the ceiling. (PANYNJ.)

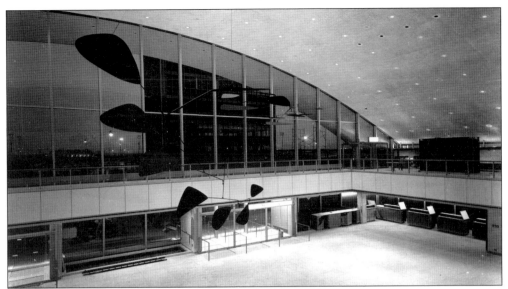

INTERIOR OF THE INTERNATIONAL ARRIVALS BUILDING, 1957. Taken just prior to its opening, the main lobby of the International Arrivals Building was dominated by a mobile designed by Alexander Calder. The design of the building eliminated congestion and achieved maximum passenger convenience by separating the various types of traffic. Incoming passengers cleared customs, claimed their baggage, and reached ground transportation all on the first floor. Outgoing passengers departed on the second floor. The Calder mobile in the center of the atrium added beauty and interest as well as reduced the vastness of the interior space. (PANYNJ.)

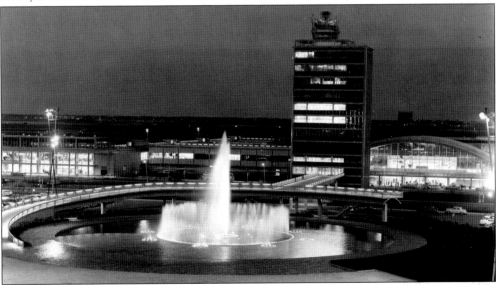

FOUNTAIN OF LIBERTY OUTSIDE THE INTERNATIONAL ARRIVALS BUILDING, 1959. In its earliest form, New York International Airport was well landscaped. The highlight was the Fountain of Liberty in International Park, located directly in front of the International Arrivals Building. The center of the park featured a 220-foot-diameter pool bordered by a spiral ramp for visitors. A fountain soared from 916 nozzles in its center to a height of 60 feet, and it was illuminated at night by 308 lamps in five colors, installed in the floor of the pool. Somewhat like Las Vegas, they produced an ever-changing spectacle on a repeating, six-minute cycle. (PANYNJ.)

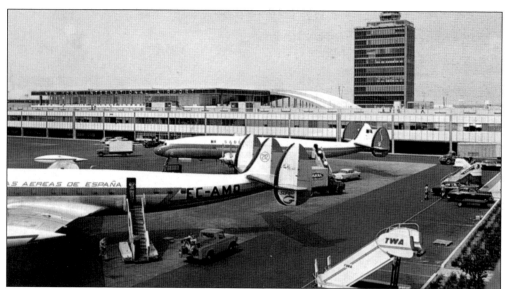

FLIGHTLINE OUTSIDE THE INTERNATIONAL ARRIVALS BUILDING, 1959. By the late 1950s, New York International Airport was being serviced by airlines from all over the world. In the foreground is an Iberian Airlines Lockheed Constellation. Iberian, the official airline of Spain, was founded in 1940 and began service to New York in 1954. In the rear is a Sabena Constellation. Sabena, the national airline of Belgium, was founded in 1923 and began service to New York in 1947. Both of these airlines switched over to Boeing 707s for transatlantic service in the early 1960s. Note the TWA air stairs on the ramp. (CAM.)

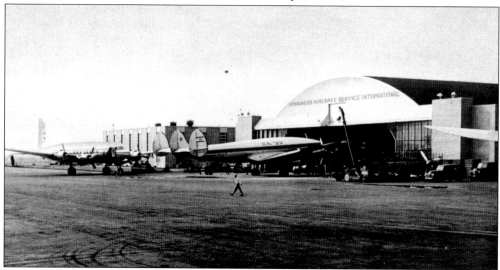

HANGAR SEVEN, LOCKHEED AIRCRAFT SERVICE INTERNATIONAL, C. 1953. In 1951, Lockheed constructed a major facility at New York International Airport to handle all types of large aircraft maintenance. Located on the north end of the field, it serviced all types of airliners but mainly Constellations and DC-6s through the 1950s and Lockheed Electras in the 1960s. This was its East Coast maintenance site, and it serviced everything from foreign airliners to military aircraft such as EC-121s and even Pres. Dwight Eisenhower's Lockheed Constellation. In 1974, Lockheed moved this facility to Texas where the costs were far less, and this hangar was converted for cargo use. (CAM.)

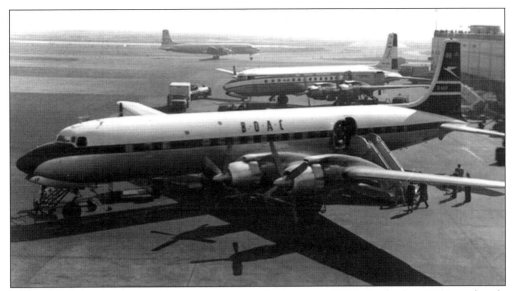

BOAC DC-7 AT NEW YORK INTERNATIONAL AIRPORT, C. 1958. In the late 1950s and early 1960s, one of the more common airliners at New York International Airport were Douglas DC-7s. The DC-7 was in production between 1953 and 1958, and it was the last major piston-engine-powered airliner built by Douglas. Popular just before the advent of jet aircraft, 348 DC-7s were produced. Pan American Airways used the DC-7 to inaugurate the first non-stop New York-to-London service. The aircraft could carry up to 105 passengers, cruising at 355 miles per hour. (Henry Holden.)

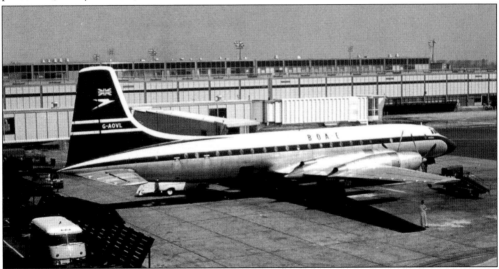

BRISTOL BRITANNIA AT NEW YORK INTERNATIONAL AIRPORT, C. 1960. The Britannia was a British long-range airliner first produced by Bristol in 1952 in order to traverse the British Empire. The aircraft had developmental problems, resulting in a delayed entry into service. By then, American and British jets were available, and only 85 were built before production ended in 1960. Nonetheless, it was a high point in turboprop design and was popular with passengers, earning the nickname "whispering giant" for its quiet and smooth flying. BOAC operated 18 between London and New York from 1957 to 1962. The Britannia could carry 139 passengers and cruised at 357 miles per hour. (CAM.)

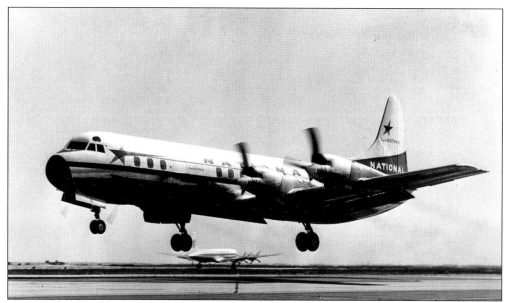

NATIONAL AIRLINES LOCKHEED L-188 ELECTRA, C. 1958. The Electra was the only large American turboprop airliner ever produced. It first flew in 1957, and it delivered performance only slightly inferior to jets but at a lower operating cost. The Electra was in production between 1957 and 1961, but only 170 were built, as production was stopped earlier than planned due to the lack of confidence in the design after two fatal crashes. The Electra could carry up to 127 passengers, cruising at 405 miles per hour. National Airlines operated a route between New York International Airport and Miami in the late 1950s. (CAM.)

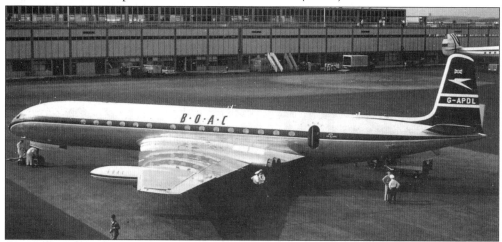

DEHAVILLAND COMET 4 AT NEW YORK INTERNATIONAL AIRPORT, 1958. The first transatlantic commercial jet flight was made by a BOAC Comet 4 from London to New York on October 4, 1958. As the first commercial jetliner, the Comet first flew in 1949 and entered service in 1952. However, following fatal crashes in 1953 and 1954 due to structural fatigue, the entire fleet was grounded, and the aircraft was redesigned, not reentering service until four years later. By this time, the much-improved Comet 4 series was available, equipped with better engines, greater fuel capacity for increased range, and a lengthened cabin for additional passengers. However, by this time, potential customers turned to the rival Boeing 707 and Douglas DC-8. The Comet 4 could carry up to 109 passengers and cruised at 500 miles per hour. (PANYNJ.)

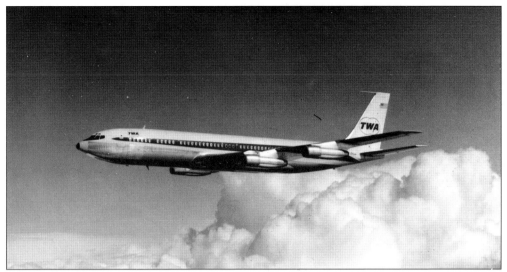

TWA BOEING 707, 1959. From the late 1950s through the early 1970s, the most common jet airliner seen at New York International Airport was the Boeing 707. America entered the age of the jet transport in July 1954 when the Boeing 707 prototype lifted off from Boeing Field. Powered by four Pratt and Whitney JT3 turbojets mounted under wings swept back 35 degrees, the Boeing 707 established the classic configuration for jetliners to come. Commercial history was made on October 26, 1958, when Pan American Airways inaugurated transatlantic Boeing 707 jet service between New York International Airport and Paris; jetliners then rapidly entered service throughout the world. (CAM.)

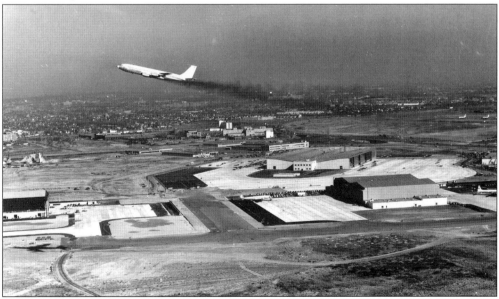

BOEING 707 TAKING OFF FROM NEW YORK INTERNATIONAL AIRPORT, 1959. Early models of the Boeing 707 featured a water-injection system for greater thrust on takeoff, resulting in a trail of sooty steam. Flights from New York to Paris on a Boeing 707 took eight hours and 41 minutes—twice as fast as a propeller plane, and it could carry twice as many passengers as the DeHavilland Comet. This view of the field is looking north towards the new cargo and maintenance hangars. (PANYNJ.)

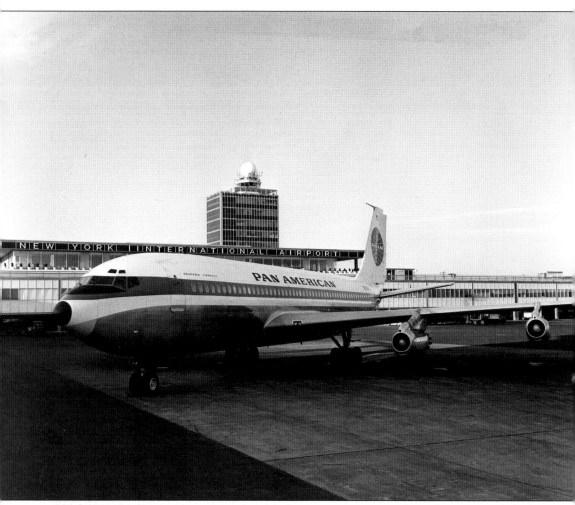

PAN AMERICAN AIRWAYS BOEING 707 ON THE FLIGHTLINE, 1959. Here are two icons of the new jet age—a Boeing 707 and the spectacular new New York International Airport. As soon as the first Boeing 707 took to the air, the company saw a flood of orders from airlines all over the world sparked by a large contract placed by Pan American Airways. Boeing funded the development of the first 707 by itself for $16 million, which was 25 percent of the company's entire value. Over the course of its production run, the Boeing 707 was modified into the greatest number of variations of any plane ever built. (PANYNJ.)

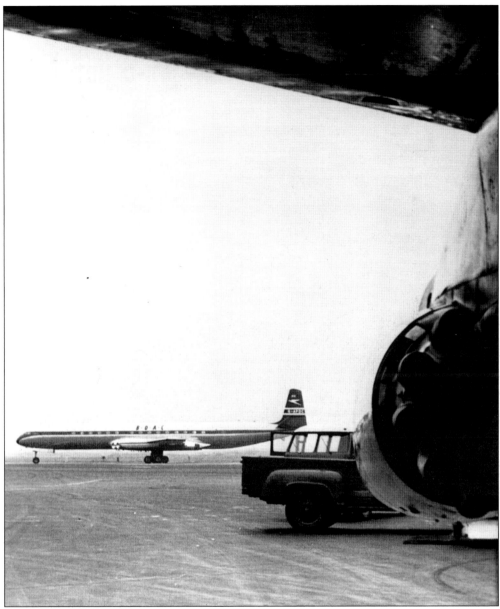

BOAC Comet 4 at New York International Airport, 1958. The stark speed difference between the Boeing 707 and Comet 4 was intentionally illustrated by Pan American Airways on November 18, 1958, as seen here. This BOAC Comet 4 is taxiing in just after landing. Pan American Airways's Boeing, whose wing and engine frame the Comet, left London 36 minutes after the takeoff of the Comet. It landed in New York 11 minutes before the Comet, having passed the airliner about 100 miles east of Boston. (CAM.)

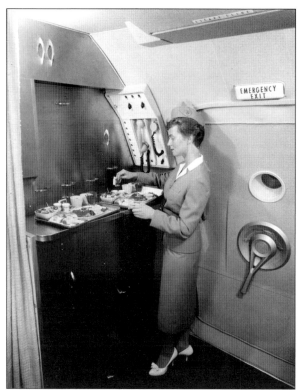

PAN AMERICAN AIRWAYS STEWARDESS AT THE GALLEY OF A BOEING 707, 1959. The height of luxury in travel, generally only the wealthy flew the oceans in Boeing 707s in the 1950s and 1960s. This was the era before airline deregulation, and nearly all passengers were treated to first-class service. By the time production ended on the Boeing 707 in 1991, over 1,000 had been produced. It carried up to 181 passengers, with a 4,300-mile range, cruising at 600 miles per hour. (CAM.)

DOUGLAS DC-8 IN THE PAN AMERICAN AIRWAYS HANGAR, 1960. Very similar in appearance and performance to the Boeing 707, the DC-8 was Douglas's first jet-powered airliner and America's second successful jet transport behind the Boeing 707. The DC-8 first flew in 1958, but the earlier availability of the Boeing 707 meant that initial sales of the DC-8 were relatively slow. However, unlike the Boeing 707, the DC-8 was offered in shorter domestic and stretched intercontinental versions right from the start, so even airlines like Pan American purchased some to complement their 707s. (CAM.)

Four

THE JET AGE
1961–1990

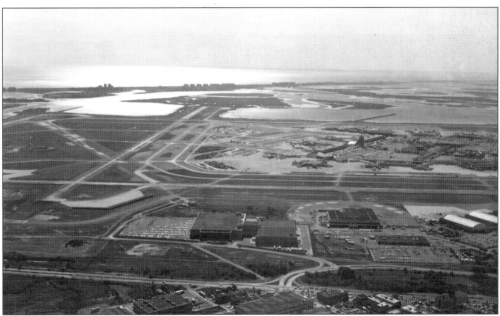

NEW YORK INTERNATIONAL AIRPORT LOOKING SOUTHWEST, C. 1962. The introduction of jets in the late 1950s, with their speed and efficiency combined with airline deregulation, triggered an exponential expansion in air travel that pushed the nation's airports, including New York International, to their limits. In 1958, jets first entered service in the United States, and all the airlines, combined, flew 34 billion passenger miles. By 1963, this number had risen to 55 billion. This startling growth set off a boom in airport expansion. Runways were lengthened, new terminals were built, and old airports were either reconstructed or replaced. In this view, the cargo and maintenance hangars are closest with the terminal city area in center right. (PANYNJ.)

CENTRAL HEATING AND REFRIGERATION PLANT, C. 1963. Built by the port authority, this central plant housed both the heating and cooling systems that served all the terminals at New York International Airport. It featured the largest single absorption-type air-conditioning system yet built, and it was also the first in which a high-temperature hot water system had been used for cooling and heating. The entire south wall was glass, so visitors could view the various colorful pumps and machines inside. (PANYNJ.)

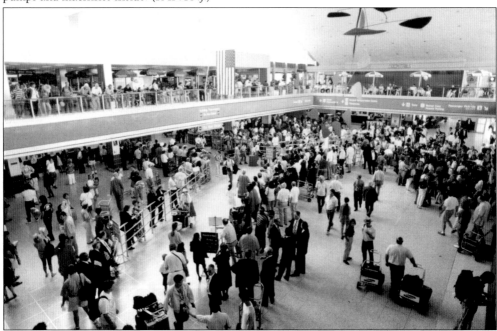

GREAT HALL OF THE INTERNATIONAL ARRIVALS BUILDING, 1963. The immense International Arrivals Building was used by all travelers departing on foreign airlines and all incoming passengers requiring customs clearance. Designed by architects Skidmore, Owings and Merrill, the arched-roof great hall featured a 40-foot mobile sculpture (upper right) by Alexander Calder. When this building was ultimately demolished, this sculpture was the one element that was saved and reinstalled in the new terminal that replaced it. (PANYNJ.)

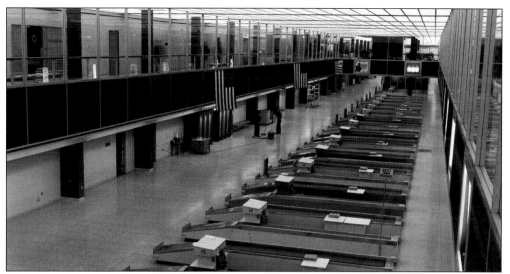

CUSTOMS HALL IN THE WEST WING OF THE INTERNATIONAL ARRIVALS BUILDING, 1963. Typical of the attention given to passenger convenience in the new airport were the streamlined customs facilities that were capable of speeding incoming passengers through customs in half the time required with the old procedures. Instead of having to crowd around a customs checkout counter, the passengers took their own baggage from a rack and went to any one of 32 supermarket-type checkout counters in each of the two customs halls in the building. New York International Airport was the first to feature this. This view was taken in the early morning hours, otherwise it would have been jammed. (PANYNJ.)

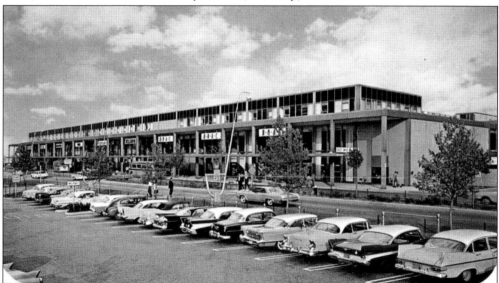

EAST AIRLINE WING BUILDING, C. 1962. Flanking the central hall of the International Arrivals Building were the twin airline wing buildings. These structures housed the stations and offices of all foreign-flag airlines serving the airport. Each airline was allowed to express its individual design preferences in its own space within the building. This layout also permitted each carrier's passengers to pass through the airport without mixing with the passengers of other airlines. BOAC, now British Airways, occupied the prime spot in the building adjacent to the central hall of the International Arrivals Building. (CAM.)

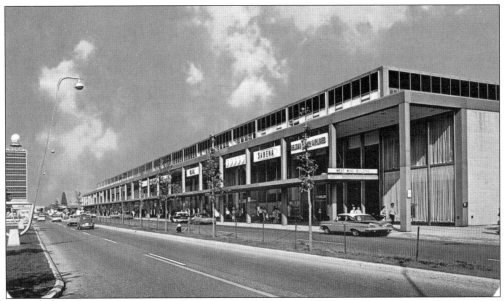

WEST AIRLINE WING BUILDING, C. 1962. Enplaning overseas passengers came directly to the individual stations in the wing buildings, proceeded with ticketing details and baggage checking, went up to a second-story waiting area, and then proceeded down to an adjoining plane station when the flight was announced. In this building, Air France occupied the prime location nearest the center of the International Arrivals Building. Together, the wing buildings had 230,000 square feet of space and offices for 14 foreign airlines. (CAM.)

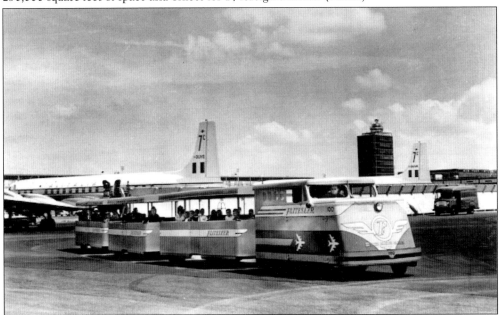

FLITESEER TRAM RIDE, C. 1962. From its inception through the 1960s, the port authority provided sightseeing rides of behind-the-scenes activities at the airport. On a Disneyland-like tram, visitors toured the airport, including a ride down the entire length of the flightline during operational periods. While spectacular, the service was halted in the late 1960s due to security and safety concerns. In the background is an Alitalia DC-7C. (PANYNJ.)

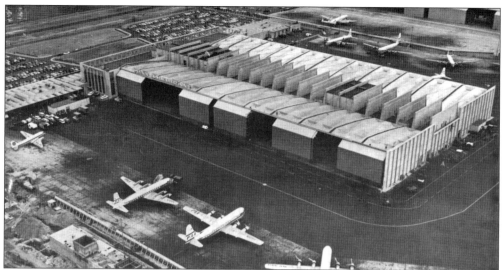

HANGAR 14, C. 1960. Pan American Airways built Hangar 14 as a maintenance facility, opening in 1958. In order to keep as much clear space as possible inside, the roof was a cantilevered structure suspended on cables almost 1,000 feet long. The largest single maintenance facility on the airport at the time, it was greatly expanded in the early 1960s to incorporate the Jet Engine Overhaul Building. This was the only complete jet engine overhaul facility on the airport. Not only could jet engines be thoroughly overhauled, Pan American Airways also had a substantial parts warehouse that supplied components to any airline that needed them. By 1963, 1,350 jet engines had been overhauled here and another 4,323 tested. (CAM.)

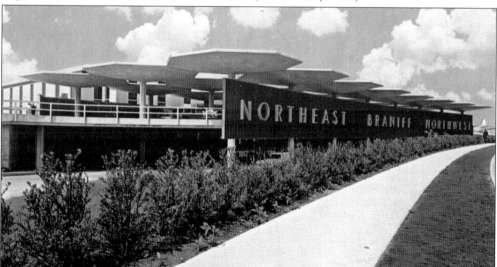

THE NORTHEAST-BRANIFF-NORTHWEST TERMINAL, C. 1963. After the International Arrivals Building and airline wings, the rest of the individual terminal space around the central loop was allocated to specific airlines. Each airline then became responsible for the design of their own terminal, resulting in a wide variety of colorful styles. At the time, these terminals were considered the pinnacle of modern design and passenger convenience. Another advantage was that the passengers of each carrier could pass through the airport without having to mix with the passengers of other lines. This 11-gate terminal, Terminal 2, opened in 1962 and was later taken over by Delta Air Lines. (CAM.)

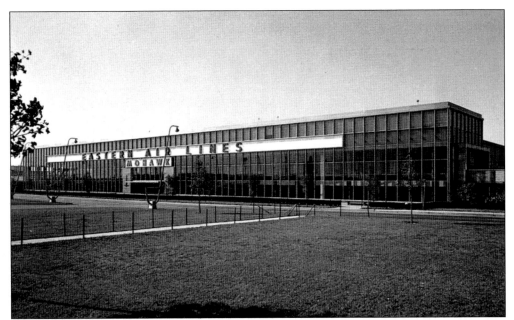

EASTERN AIR LINES TERMINAL, C. 1963. Opened in 1959, this $21 million terminal handled 169 daily flights by 1963. Up until 1963, this was the largest of the airport's individual terminals. Its main lobby was the size of a football field, and ramps in its interior were suspended by a series of stainless steel cables at irregular angles, creating an unusual visual pattern. Called Terminal 1, it was demolished in 1995 for a much larger, more spectacular space. (CAM.)

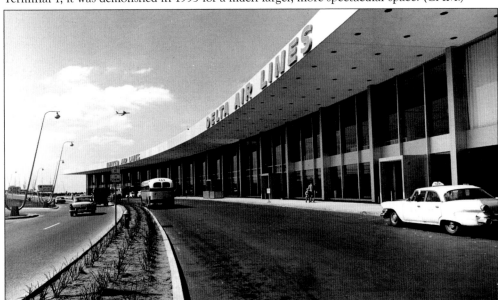

THE UNITED AIRLINES/DELTA AIR LINES TERMINAL, 1961. Opened in 1959, this was the first individual, or unit terminal to open at New York International Airport. As new unit terminals opened on a yearly basis from the late 1950s into the mid-1960s, travelers and visitors were amazed by the colorful varied terminals and the spectacular landscaping. New York International Airport was the first in the world to adopt this decentralized system, and it became the model for future airports worldwide. (PANYNJ.)

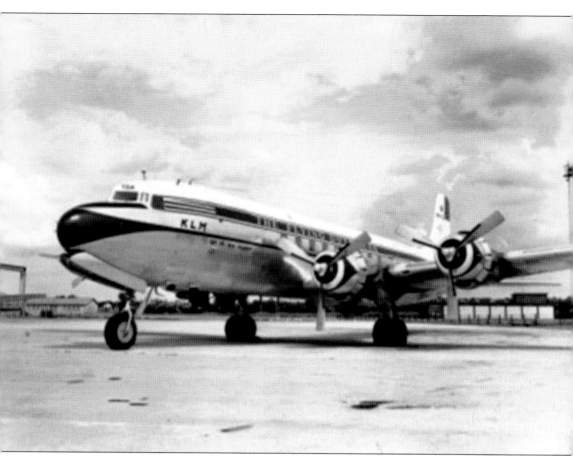

KLM Royal Dutch Airlines DC-6 at New York International Airport, c. 1960.
KLM Royal Dutch Airlines is the national airline of the Netherlands. Founded in 1919, it is the oldest airline in the world still operating under its original name. In 1946, it was the first continental European airline to launch scheduled service to New York. In the early 1960s, DC-6 propliners were replaced by DC-8 jets on transatlantic routes. (CAM.)

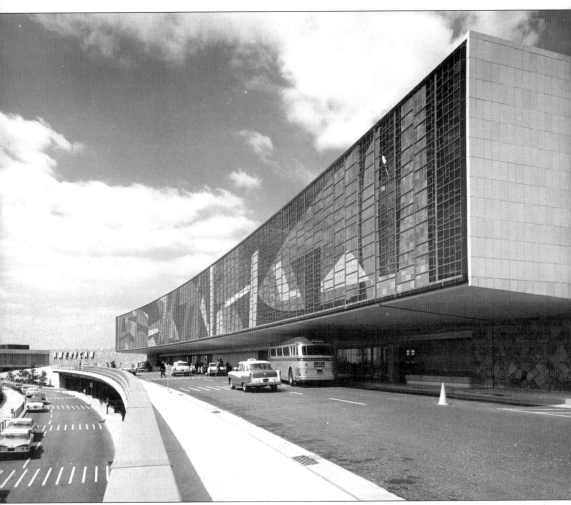

THE AMERICAN AIRLINES TERMINAL, 1961. Designed by the firm of Kahn and Jacobs, the focal point of the terminal was a 317 foot long stained-glass mural by the artist Robert Sowers across its facade. This stained-glass mural, with some 8,000 individual pieces, was the largest ever created at the time. This terminal also adopted the model, first set at LaGuardia Airport in 1939, of separating arriving and departing passengers on to different levels. (PANYNJ.)

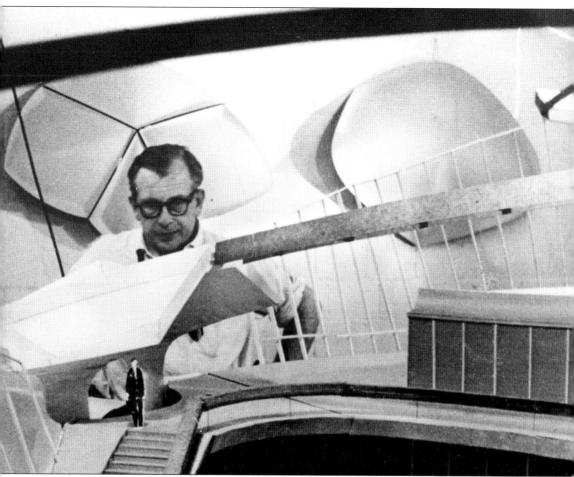

ARCHITECT EERO SAARINEN DESIGNING THE TWA TERMINAL, 1958. The most unique structure at the airport, the TWA terminal, was designed by noted Finnish architect Eero Saarinen. He imagined the abstract structure (first sketched on the back of a napkin) to resemble a giant bird about to take flight, and he designed it as one giant unified piece of sculpture—a symbol of flight. Originally designated Terminal 1 but later renamed Terminal 5, the unique structure opened to great acclaim in 1962. (CAM.)

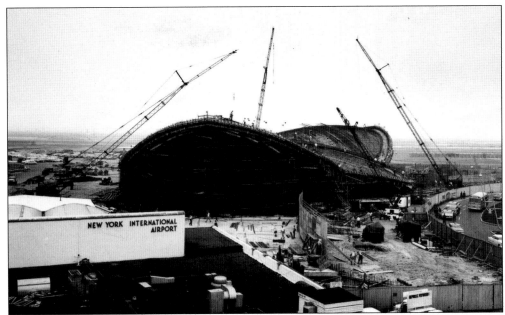

TWA Terminal under Construction, 1960. The concrete roof of the terminal consisted of four individual arch cantilevered shells one and a quarter acre in size. The roof weighed 11.5 million pounds and varied in thickness from eight inches at the edge to 44 inches in the center. More than 20,000 cubic yards of concrete went into the unique structure, requiring more than 2,500 truckloads of concrete. (PANYNJ.)

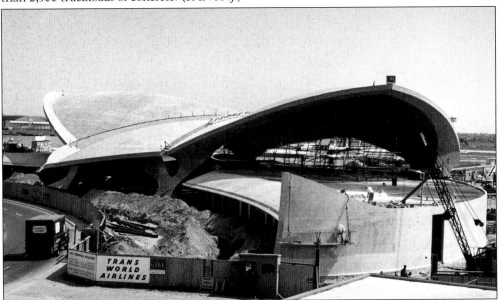

TWA Terminal under Construction, 1961. The TWA building also featured two huge glass walls consisting of 8,500 square feet of one-quarter-inch-thick glass that was tinted green and specially treated to ensure effective temperature control inside. The weight of the glass alone was 17 tons. The beaklike extension at the front of the building was actually a rainwater drain. It created an aesthetic waterfall during a rain, splashing into a large pool beside the front entrance. (PANYNJ.)

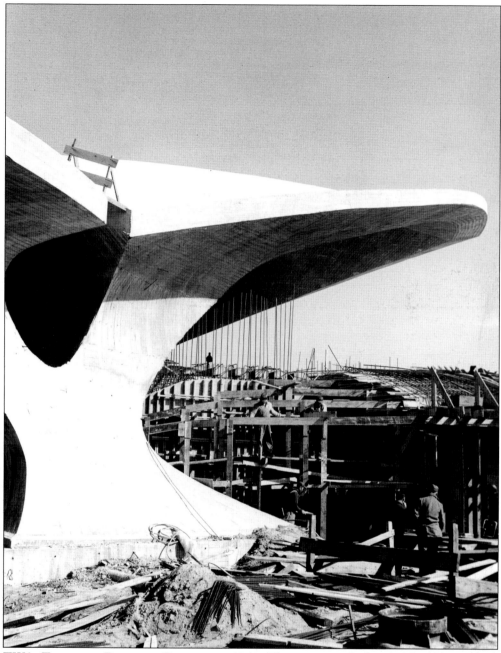

TWA Terminal Pouring Concrete, 1961. The structure had a 315-foot-long central public-use area roofed over by four interacting concrete vaults and two finger waiting-room structures, each of which served seven plane stations. The huge cantilevered vaults, the larger two of which soared to a height of 54 feet, vested on but four points and were articulated by bands of skylights. (CAM.)

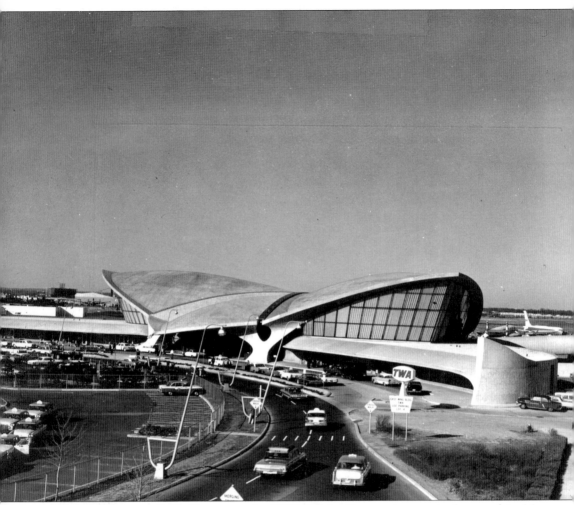

TWA TERMINAL, 1962. Known as the TWA Flight Center, the terminal opened in May 1962 to great acclaim. Sculpted as an abstract symbol of flight, it is considered one of the most architecturally distinguished airport terminals in the world. The terminal was also among the first to feature two-way moving sidewalks. The architect, Eero Saarinen, died several months before the building opened. (PANYNJ.)

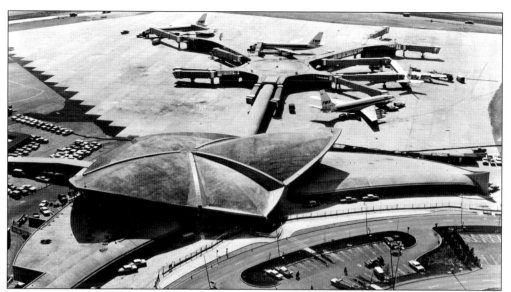

TWA FLIGHT CENTER, 1963. The soaring central structure, which suggested a giant bird about to takeoff, contained check-in, baggage claim, and main waiting areas. A passageway led to the flight wing, which featured a comfortable lounge for each of the seven gate positions, four of which are filled here with Boeing 707s. The seven aircraft positions beside the flight wing were equipped with telescopic jetways—the first in the world. Now for the first time, passengers would not be exposed to outside weather between their airplane and the terminal by using the jetways. (CAM.)

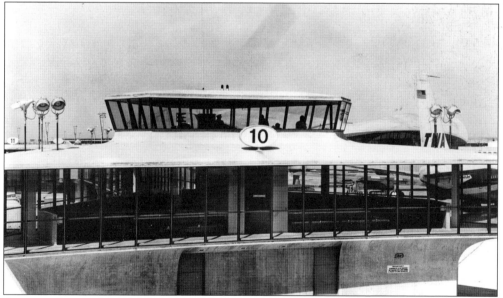

GROUND CONTROL TOWER ATOP TWA FLIGHT WING, 1963. TWA had its own control tower on top of the flight wing staffed by its own personnel, with a clear view of the entire ramp area. By radio and Teletype equipment, the tower personnel kept an up-to-the-minute record of when flights would arrive and which were ready to depart. In order to facilitate more efficient aircraft servicing resulting in better on-time reliability, controllers could talk with an aircraft in flight, contact any TWA station at the airport, and coordinate ground service. (CAM.)

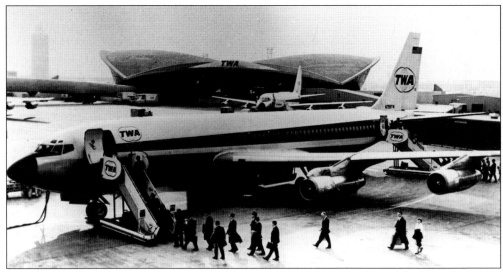

PASSENGERS BOARDING A BOEING 707 OUTSIDE THE TWA FLIGHT CENTER, 1965. The terminal also incorporated three revolutionary baggage carousels that made possible the speediest baggage delivery available at any terminal in the world. The carousels were 20 feet in diameter and rotated at 65 feet per minute. Baggage was carried to them by conveyor belts from the field side of the terminal. These revolutionary carousels were soon incorporated at new airline terminals all over the world. Designed for propliners in the 1950s, TWA had great difficulty keeping up with the steadily increasing jet traffic, thus not all aircraft could use one of the new jetways, as seen here. (CAM.)

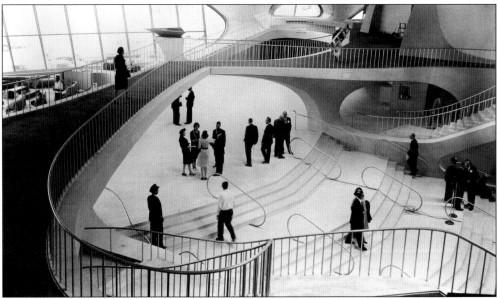

INTERIOR OF THE TWA TERMINAL, 1963. The interior of the new terminal was a dramatic, spacious, vaulted, pillarless space. Just inside the entrance was an information desk and flight-information boards. Stairways led from this check-in area to the main concourse and then to an upper level where a slender bridge linked the restaurant and lounge areas. The pristine white interior was broken only by red carpeting and upholstered seats. The upper level housed a coffee shop, Cosmopolitan Restaurant, bar, and the Ambassadors Club. (CAM.)

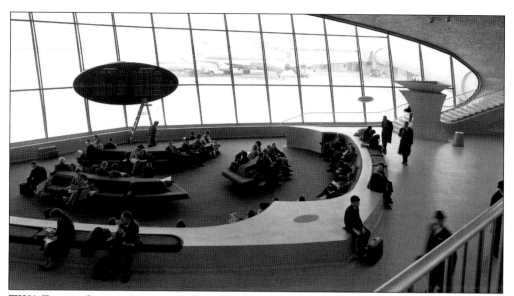

TWA FLIGHT CENTER INTERIOR, 1963. On the side toward the field in a sunken, plant-bordered waiting area carpeted in TWA deep burgundy was a lounge with upholstered chairs, arranged in theater fashion, from where passengers could watch field operations while waiting for their flight. Along the entrance side of this main waiting area under a balcony was a series of shops. Even after the demise of TWA, the structure was not demolished and has since been renovated and expanded as the new hub terminal of JetBlue Airways. It is still the only building at JFK airport on the National Register of Historic Places. (PANYNJ.)

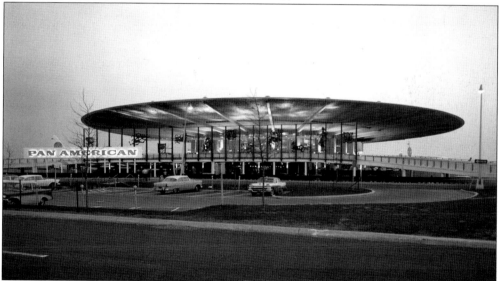

PAN AMERICAN WORLDPORT, 1962. The Pan American Worldport, now Terminal 3, opened in 1962. The unique design featured a large, elliptical roof suspended by 32 sets of radial posts and cables. The roof extended far beyond the base of the terminal and covered the passenger loading area in an effort to keep passengers out of the weather. This was one of the first airline terminals in the world to feature jetways, albeit in this case they were more like mobile gangplanks. These walkways connected the terminal to a docked aircraft rather than having to board the plane outside via air stairs. (PANYNJ.)

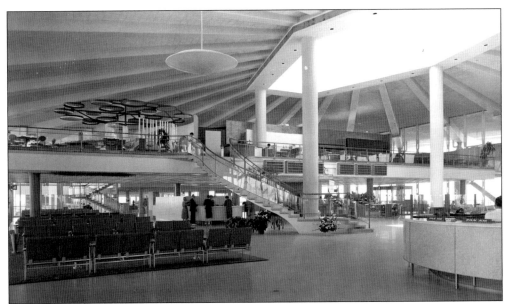

INTERIOR OF THE PAN AMERICAN WORLDPORT, 1962. Designed by the firm of Tippets-Abbett-McCarthy-Stratton, the terminal was basically a huge elliptical concrete and steel canopy suspended on a network of cables over a glass drum. The spacious interior and the exterior under the canopy were illuminated via several huge glass skylights. As in other new terminals, arriving and departing passengers were separated on to different levels. In its earliest form, the terminal had nine gates. (PANYNJ.)

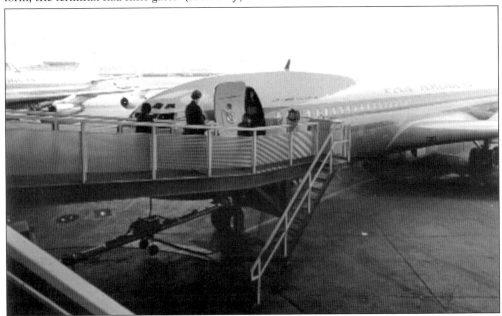

PASSENGERS BOARDING A BOEING 707, PAN AMERICAN WORLDPORT, C. 1964. A unique innovation at the time, passengers boarded aircraft under the huge canopy via mobile, open jetways, which bridged the concourse level with the aircraft entrance. The terminal also contained Clipper Hall, Pan American Airways's own aviation museum, filled with an exhibit of the airline's artifacts and ephemera dating back to the early 1930s. (PANYNJ.)

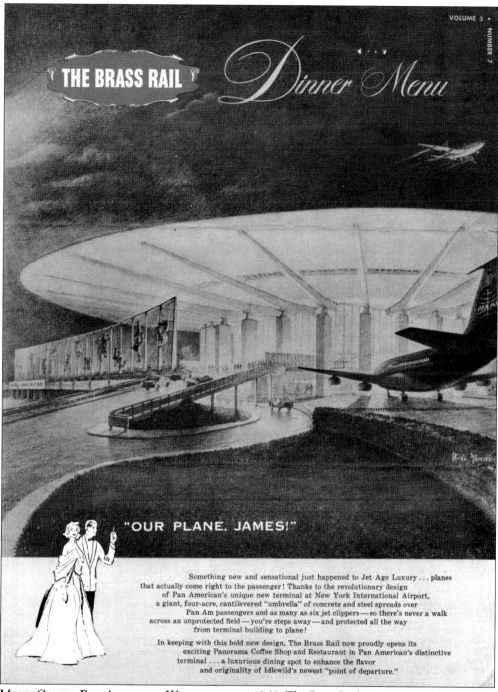

THE BRASS RAIL *Dinner Menu*

"OUR PLANE, JAMES!"

Something new and sensational just happened to Jet Age Luxury ... planes
that actually come right to the passenger! Thanks to the revolutionary design
of Pan American's unique new terminal at New York International Airport,
a giant, four-acre, cantilevered "umbrella" of concrete and steel spreads over
Pan Am passengers and as many as six jet clippers — so there's never a walk
across an unprotected field — you're steps away — and protected all the way
from terminal building to plane!

In keeping with this bold new design, The Brass Rail now proudly opens its
exciting Panorama Coffee Shop and Restaurant in Pan American's distinctive
terminal ... a luxurious dining spot to enhance the flavor
and originality of Idlewild's newest "point of departure."

MENU COVER, PAN AMERICAN WORLDPORT, C. 1963. The Brass Rail restaurant on the elevated second floor of the terminal offered passengers and visitors a view of the spacious terminal interior and the airfield. From the cover illustration, one can see how the airliners tucked under the huge cantilevered roof. This was the only terminal ever built that incorporated this unique feature. The development of enclosed jetways rendered this novel concept unnecessary, but it was spectacular in its day. (CAM.)

Special GIANT Cocktails and Drinks

range Blossom	.70
ck Rose	.70
e Old Fashioned	.80
cardi Cocktail	.80
aiquiri	.80
anhattan	.85
artini	.85
ubonnet Cocktail	.75
ibson	.85
hiskey Sour	.85
dka Martini	.85
lexander (Gin)	.85
otch Old Fashioned	.90
oody Mary	.90
de Car - Screwdriver	.95
ozen Daiquiri	.90
lexander	.95
rasshopper Cocktail	.95
ob Roy	1.00
arlett O'Hara	.90
inger	1.00
otch Sour	.95

Rye Whiskey

eischmann's	.75
olden Wedding	.75
perial - Carstairs	.75
M De Luxe	.75
agram's 7-Crown	.80
alvert's Reserve	.80
chenley Reserve	.80
& T Private Stock	.80
ur Roses	.80
anadian Club	.85
agram's V. O.	.85
arrington	.85

Bourbon Whiskey

arly Times	.80
ourbon De Luxe	.80
ld Crow	.80
W. Harper	.90
ld Fitzgerald	.90
ld Forester	.90
ld Grand-Dad	.90
ld Taylor	.90

Long Drinks

odka Collins	.80
om Collins	.80
oe Gin Collins	.80

Appetizers

Dubonnet Aperitifs 40c.

CHERRYSTONE OR LITTLE NECK CLAMS ON HALF SHELL .65 MELON IN SEASON .

CHILLED TOMATO JUICE .25 TROPICAL FRESH FRUIT CUP .45

CHOPPED CHICKEN LIVERS .50 FRESH FLORIDA SHRIMP COCKTAIL .95

MARINATED HERRING, CREAM SAUCE .50 CHILLED HALF GRAPEFRUIT .45

PINEAPPLE, GRAPEFRUIT OR APPLE JUICE .30

Soups

Imported Sherry 45c.

	Cup	Plate		Cup	Pl
CREAM OF TOMATO with Croutons	.35	.50	MANHATTAN CLAM CHOWDER	.35	.
CONSOMME, Fine Noodles	.30	.45	OLD FASHIONED CHICKEN, Rice	.35	

Brass Rail Specialties

Sauterne or Chablis 35c.

(Complete Dinner Served with Dinner Appetizer, Salad, Dessert and Beverage)

	A LA CARTE	COM DI
GOLDEN FRIED SEA SCALLOPS, Tartar Sauce, French Fries, Cole Slaw	2.25	3.
BROILED WHOLE FLOUNDER, Parsley Potato and Garden Peas	2.10	2.
BROILED HALIBUT STEAK, Parsley Potato and Fresh String Beans	2.10	2.
JUMBO FANTAIL SHRIMP (deep fried), Tartar Sauce, French Fries, Cole Slaw	2.25	3.
FRESH LOBSTER NEWBURG EN CASSEROLE, Garden Peas	2.60	3.
SPAGHETTI CARUSO WITH CHICKEN LIVERS, Tomato Sauce	2.00	2.
BROILED OR FRIED SPRING CHICKEN, Candied Sweet Potato, Garden Peas	2.20	2
BREADED MILK FED VEAL CUTLET, Tomato Sauce, Spaghetti, Garden Peas	2.80	3.
BRASS RAIL BAKED VIRGINIA HAM with Baked Beans and Cole Slaw	2.50	3.
ROAST TOM TURKEY, Chef's Dressing, Candied Sweets, String Beans	2.80	3
OUR FAMOUS CORNED BRISKET OF BEEF AND CABBAGE, Parslied Potato	2.90	3
MILK FED VEAL CUTLET PARMIGIANA, Spaghetti Italienne, Garden Peas	2.80	3
BRASS RAIL BAKED VIRGINIA HAM STEAK, Pineapple and Prune, Candied Sweets	2.50	3.
BROILED CHOPPED BEEFSTEAK, French Fried Potatoes, Green Peas	2.35	3.
GRILLED JERSEY PORK CHOPS, Apple Sauce, French Fried Potatoes, Garden Peas	2.50	3
BROILED SPRING LAMB CHOPS, Lima Beans, French Fried Potatoes	3.00	3
BROILED FILET MIGNON, Mushrooms Saute, Baked Idaho Potato, Broccoli Polonaise	3.75	4
BROILED PRIME SIRLOIN STEAK, Brass Rail Salad Bowl, Baked Idaho Potato	4.95	5
BROILED ROCK LOBSTER TAIL, Drawn Butter, French Fried Potatoes, Cole Slaw	3.20	3
PRIME RIBS OF BEEF AU JUS, Baked Idaho Potato, Broccoli Polonaise	3.50	4.

Salads and Cold Buffet

Burgundy or Claret 35c.

CHEF'S SALAD BOWL: Tossed Garden Greens, Julienne of Turkey and Cheese l

FRESH CHICKEN SALAD, Quartered Egg, Mayonnaise Dressing 2

PLATTER OF JUMBO FLORIDA SHRIMP on Crisp Lettuce, Sliced Egg and Tomato Wedges ... 2

ASSORTED COLD CUT PLATTER: Turkey, Ham, Swiss Cheese, Potato Salad, Cole Slaw 2

Desserts

Creme de Menthe Frappe 85c.

SNOW WHITE CHEESE CAKE .55 GREEN APPLE PIE .35 A LA MODE

CHOCOLATE CREAM PIE, Whipped Cream .45 APPLE CRUMB CAKE .40 A LA MODE

OUR FAMOUS COCOANUT CUSTARD PIE .45 CHOCOLATE OR RICE PUDDING

FRENCH ICE CREAM OR SHERBET .40 RASPBERRY OR CHOCOLATE PARFAIT

HOME MADE LAYER CAKE .40 A LA MODE .55 FRESH STRAWBERRY SHORTCAKE

FRUIT JELL-O, Whipped Cream .35 COMPOTE OF FRUIT

MENU OF THE BRASS RAIL RESTAURANT, 1962. The restaurant inside the Pan American Worldport was as fine as one could find in Manhattan in its day. It was an era in commercial aviation full of glamour and excitement and when only the rich could afford to fly. Other people could go to the airport just to watch the sleek new airliners or to eat a fine meal. Although by

80

THE BRASS RAIL

"SUMMER IN NEW YORK" DINNER $4.50

Louisiana Shrimp Cocktail or Fantasy of Fresh Fruits

BROILED FILET MIGNON OF "BLUE RIBBON" BEEF with Sliced Mushrooms
Baked Idaho Potato Broccoli Polonaise

Tossed Green Salad

Sunset Parfait or Choice of Dinner Desserts

Tea Coffee Milk

Dinner

Tomato Juice Cocktail
Chilled Country Apple Juice
Tropical Fresh Fruit Cup
Anchovies on Lettuce, Citron
Cream of Tomato Soup

Cherrystone Clam Cocktail
Chopped Fresh Chicken Livers
Marinated Herring, Cream Sauce
Chilled Melon in Season
Consomme Alphabet

BAKED FILET OF FRESH BOSTON HADDOCK with Creole Sauce,
 Parslied Potato, Fresh Corn on the Cob 2.85

ROAST SPRING CHICKEN, Chef's Dressing, Giblet Gravy,
 Candied Sweet Potato, Peas and Mushrooms Saute 2.95

GOLDEN FRIED FANTAIL SHRIMP,
 Tartar Sauce, French Fried Potatoes, New England Cole Slaw 3.00

BROILED CHOPPED PRIME BEEFSTEAK, Bordelaise Sauce,
 Lyonnaise Potatoes, String Beans 3.10

BREADED MILK FED VEAL CUTLET CONTINENTAL,
 Tomato Sauce, Italian Spaghetti, Peas and Mushrooms Saute 3.55

OUR FAMOUS ROAST PRIME RIBS OF BEEF AU JUS,
 Baked Idaho Potato, Broccoli Polonaise 4.25

TOSSED GREEN SALAD, French Dressing

Ice Cream Cocoanut Snowball with Chocolate Sauce

Brass Rail Cheese Cake Green Apple Pie
Fruit Jell-O, Whipped Cream Blueberry Crumb Pie
Mixed Fresh Fruits Chocolate Layer Cake
Cheese and Crackers Chocolate Parfait
French Ice Cream or Sherbet Chocolate Chip Mint Ice Cream

today's standards, the prices seem cheap (note the extensive drink menu), this was an upscale
restaurant in 1962. Airport food courts were then unknown; when one went to the airport, one
expected to eat well. (CAM.)

AEROFLOT (SOVIET AIRLINES) TU-114, 1963. Developed as an intercontinental airliner based on the TU-95 strategic bomber, the TU-114 was a large airliner with four powerful Kuznetsov engines, driving eight massive counter-rotating propellers. It came as a surprise to many in the west that a propeller-driven aircraft could operate at jetlike speeds. By 1950s standards, it was huge, with accommodation for up to 220 passengers cruising at 480 miles per hour. The TU-114 had a fairly short commercial life, being operated by Aeroflot on regular flights from 1962 to 1974. While in service, it was known for its reliability, speed, and fuel economy. It is pictured here at New York International Airport. (CAM.)

POSTAL COVER, NEW YORK INTERNATIONAL AIRPORT, 1963. New York International Airport was renamed John F. Kennedy International Airport in December 1963, one month after the assassination of the popular president. The airport's original call sign and baggage tag designation was KIA (for Kennedy International Airport), but due to the negative connotations the term had during the Vietnam War, it was changed to JFK in 1968, as it remains today. This postal cover marks the last day that mail was cancelled AMF (Airport Mail Facility) Idlewild. (CAM.)

MODEL OF THE PAN AMERICAN WORLDPORT EXPANSION, 1969. Almost immediately upon its opening, it was evident that the new terminal could not handle the growing volume of jet traffic. Thus an addition was planned for the rear of the building six times larger than the original terminal to provide an additional eight gates. This new addition included both modern jetways as well as docks so passengers could walk from the terminal directly to their aircraft. Note the inclusion of models of the Concorde, as Pan American Airways was originally planning on purchasing some in the late 1960s. (CAM.)

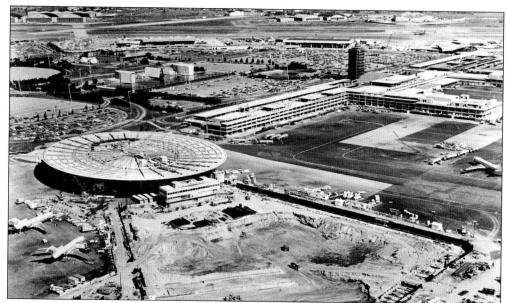

JFK Airport Looking Northwest, 1973. The International Arrivals Building, with the control tower fronting it, is visible to the right, and the two airline wings extend from it. In front center is the Pan American Worldport with its large, new addition under construction. The two prime locations for the unit terminals at JFK were Pan American Airways just to the left of the International Arrivals Building, with the TWA Flight Center just visible to the upper right. The airport's three chapels are visible in the top left, bordering the reflecting pool. (CAM.)

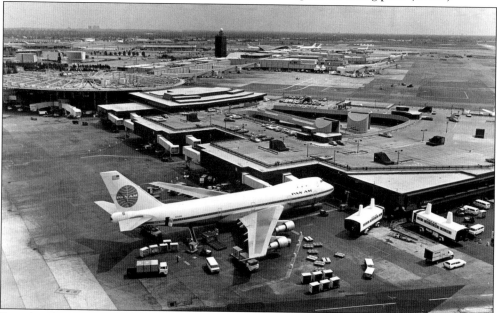

Pan American Worldport Addition, 1970. The large triangular expansion, which greatly increased Pan American Airways's capacity, is in front center, with a new Boeing 747 at a dock. At the time, this was the largest terminal in the world operated by a single carrier. The two rectangular white vehicles in the lower right were to transport passengers en masse from the terminal to their aircraft out on the tarmac whenever all the gates were occupied. (PANYNJ.)

JFK Airport Looking South, 1964. Through the first half of the 1960s when all the new terminals were being built, the port authority was also undertaking major roadway improvements at the airport. This view shows the greatly expanded road system at the 150th Street entrance to the airport. In the center can be seen the airport's famous aircraft overpass that connected the runways to the central terminal area. (PANYNJ.)

OUR LADY OF THE SKIES CHAPEL, C. 1962. JFK airport was among the first in the world to feature three fully developed chapels on airport property. This Catholic chapel was first built in 1955 but was demolished and rebuilt in 1966 as part of the expanded Tri-Faith Plaza development. The sculpture of the Virgin Mary atop the Constellation propeller was salvaged and hung above the altar of the church that replaced it. (CAM.)

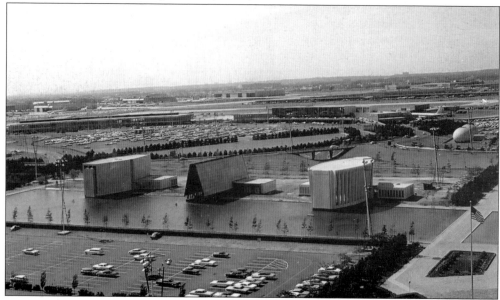

THE CHAPELS OF TRI-FAITH PLAZA, C. 1970. These Catholic, Protestant, and Jewish chapels were the first ever built on the property of an airport terminal through joint public subscription. Collectively known as Tri-Faith Plaza, they were built on a three-acre plot located on a reflecting pool opposite the International Arrivals Building in the middle of terminal city. From left to right are the Jewish, Protestant, and Catholic chapels. (PANYNJ.)

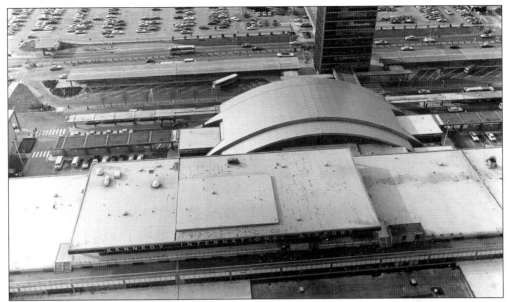

THE INTERNATIONAL ARRIVALS BUILDING, CONTROL TOWER, AND TRI-FAITH PLAZA, c. 1967. Located in the center of the airport, the chapels of Tri-Faith Plaza (upper left) served travelers, airport workers, and members of nearby communities. The chapels were designed by noted architects, reflecting the stark modernism of other JFK airport structures. Note that the large sign on the field side of the International Arrivals Building, formerly reading, "New York International Airport," now reads, "Kennedy International Airport" in the same font. (PANYNJ.)

OBSERVATION DECK OF THE INTERNATIONAL ARRIVALS BUILDING, 1968. When the new International Arrivals Building was designed in the 1950s, architects drew on the previous success of the central terminal at LaGuardia Airport and the first terminal at New York International Airport and included a spacious outdoor observation deck. Located on the roof level, visitors could watch field activities from a 4,000-foot-long observation deck extending the entire length of the building—and on nice afternoons, many did. The deck was closed in the 1980s for security concerns and was not even considered in the design of any of the new terminals. (Christopher Patti.)

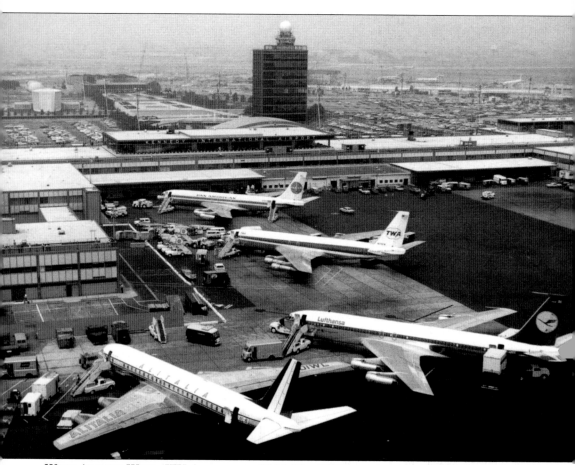

WEST AIRLINE WING, JFK AIRPORT, C. 1966. The 1960s was the era of the Boeing 707 at JFK airport. The speed and efficiency of the aircraft brought about a revolution in aviation. For the first time, almost anyone could afford to fly, and most did. Here are 707s of Alitalia, Lufthansa, TWA, and Pan American Airways all being serviced at the airline wing. Note there are still no jetways, so passengers continued to cross the tarmac and use air stairs. (PANYNJ.)

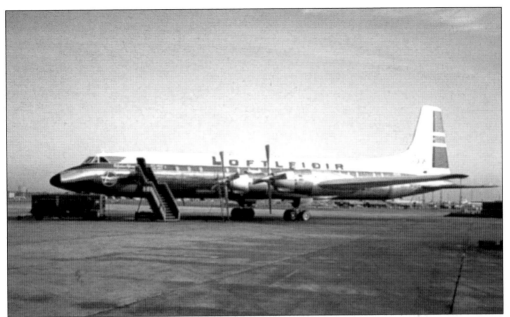

LOFTLEIDIR ICELANDIC CL44-J AT JFK AIRPORT, 1965. Loftleidir Icelandic was a private airline founded in 1944 in Iceland. It merged with Flugfelog Islands airline in 1973 to form Icelandair. The CL-44 was a Canadian turboprop airliner and cargo aircraft that was developed in the late 1950s. Loftleidir Icelandic was the only passenger operator of the CL-44J, which carried 189 passengers and cruised at 402 miles per hour. (PANYNJ.)

LOFTLEIDIR STEWARDESSES AT JFK AIRPORT, C. 1965. As it was one of the world's more important airports, airlines often took publicity photographs at JFK. In this photograph, shot on the field side of the International Arrivals Building, stewardesses hold a model of Loftleidir's new DC-8. Loftleidir (now Icelandair) has operated continuously from JFK airport since its founding in 1948. In the 1960s, the airline pioneered low-cost service across the Atlantic Ocean from New York to Luxembourg, using DC-8s. These were its first jets. (PANYNJ.)

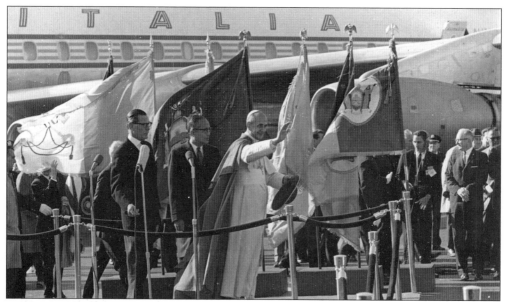

POPE PAUL VI ARRIVING AT JFK AIRPORT, OCTOBER 1965. Through the 1960s, when it was one of the few aviation ports of entry into the United States, JFK airport was considered the "Aerial Gateway to America." Virtually all dignitaries, movie stars, and diplomats who arrived in America did so here. Thus newspapers and wire services kept reporters stationed on the field, as each new arrival was newsworthy. Here Pope Paul VI arrives aboard an Alitalia Boeing 707. (PANYNJ.)

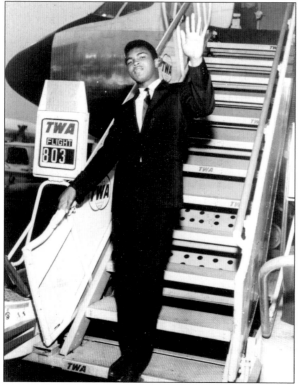

CASSIUS CLAY JR. ARRIVING ABOARD A TWA BOEING 707, 1963. Cassius Clay Jr., born in 1942, was a three-time world heavyweight boxing champion. Clay changed his name to Muhammad Ali after joining the Nation of Islam in 1964. At the time of his arrival in New York, the young fighter had amassed a record of 19-0 with 15 knockouts. As he was then a contender for Sonny Liston's heavyweight title, the media followed his every move. (PANYNJ.)

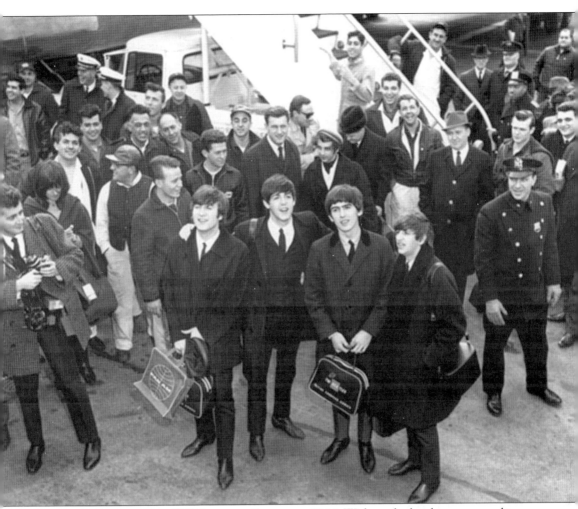

THE BEATLES ARRIVE AT JFK AIRPORT, FEBRUARY 1964. Without doubt, the most tumultuous arrival ever at JFK airport was by the Beatles in the winter of 1964. Arriving aboard a Pan American Airways Boeing 707, the group was greeted by a crowd of thousands, including many pressed to the rail of the observation deck of the International Arrivals Building. They were about to make a noteworthy appearance on *The Ed Sullivan Show* in New York City. (PANYNJ.)

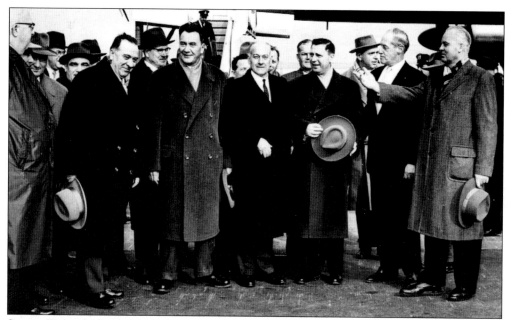

SOVIET DIPLOMATS ARRIVING IN NEW YORK, 1961. Foreign leaders and diplomats arriving in America usually made their first public appearances at JFK airport. Here a group of diplomats from the Soviet Union have arrived in the United States aboard a TU-114. On the far right is Mikhail Menshikov, Soviet ambassador to the United States. The group was making a tour of American cultural and industrial sites. (CAM.)

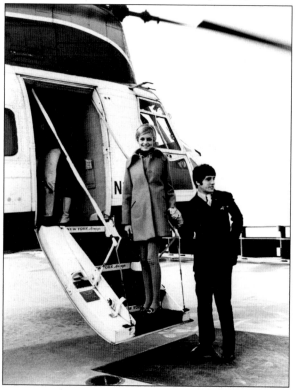

LESLEY "TWIGGY" HORNBY AT JFK AIRPORT, 1968. From the early 1960s until the late 1980s, New York Airways operated a shuttle service from the top of the Pan American Airways building in Manhattan to JFK, using Boeing Vertol helicopters so that wealthy or famous passengers could avoid the road traffic. The service was frequented by politicians, VIPs, and movie stars. Here famed model Lesley "Twiggy" Hornby departs JFK after arriving on a BOAC flight from London. (CAM.)

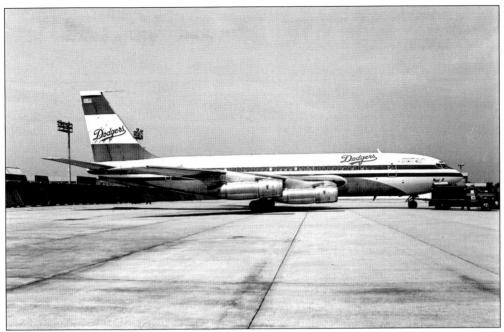

LOS ANGELES DODGERS BOEING 707 AT JFK AIRPORT, 1983. From the early 1940s, baseball teams traveled by air to road games, first on chartered commercial airliners then later on aircraft of their own. The Los Angeles Dodgers purchased this Boeing 707 in the mid-1960s, which they flew into the mid-1980s. The team was in town to play the New York Mets. (CAM.)

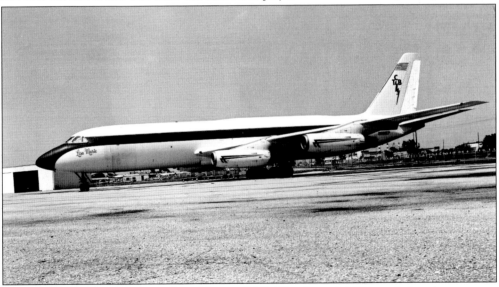

ELVIS PRESLEY'S CONVAIR 880 *LISA MARIE*, 1976. The Convair 880 was designed to compete with the Boeing 707 and DC-8 as a smaller, faster transport. This was a niche no one wanted, and only 65 were built between 1959 and 1963. Given its name because it traveled 880 feet per second, Convair took a huge loss on the project due to the lack of sales. Elvis Presley purchased this Convair from Delta Air Lines in 1975 for $250,000. Reregistered as N880EP, he named it the *Lisa Marie* after his daughter and had the interior refitted as the most luxurious private plane of its day. (CAM.)

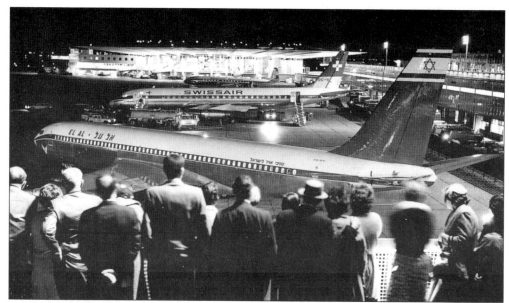

JFK AIRPORT FLIGHTLINE, C. 1965. Even at night, crowds stood on the observation deck of the International Arrivals Building to watch friends and family depart or just view the exciting airport action. In the days before jetways, one could just yell down to people getting on or off the planes. In front is an El Al Israel Airlines Boeing 707, 4X-ATA, which was El Al's first jet aircraft. In the rear is a Swissair DC-8 with the brightly illuminated Pan American Worldport in the rear. (PANYNJ.)

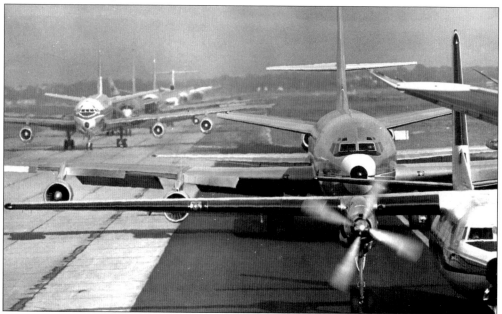

TRAFFIC AT JFK AIRPORT, 1965. During the 1960s, JFK experienced an exponential growth in air traffic. At the same time, the center terminal area was expanded considerably despite the fact that the airport could not expand beyond its then-present perimeter. Due to this growth, some runways had to be sacrificed, leaving the airport with only two pairs of parallel runways that it continues to use to this day. (PANYNJ.)

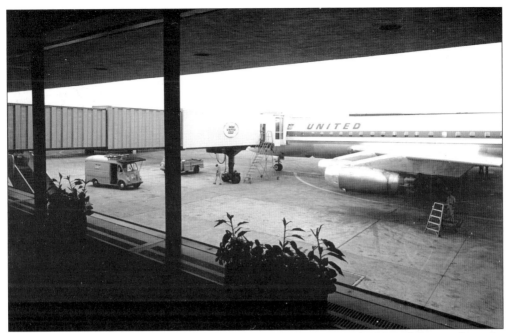

UNITED AIRLINES TERMINAL, 1962. JFK was the first airport in the United States, if not the world, to use jetways for passengers to board aircraft. The concept of people walking directly from the terminal into an airplane was a novel, if not radical, idea. Here a United Airlines DC-8 is being prepared for takeoff at their new terminal in New York. (PANYNJ.)

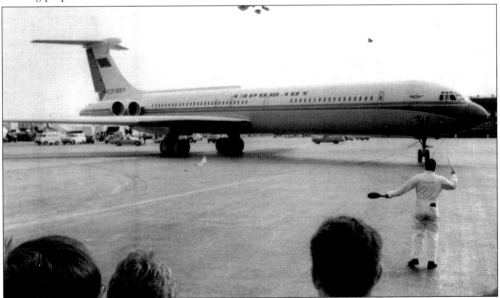

AEROFLOT IL-62 AT JFK AIRPORT, 1968. The entire evolution of the jet airliner can be witnessed in aircraft seen at JFK airport. From the Avro Jetliner to the Airbus A380, JFK has seen it all. Here a Soviet IL-62 has just arrived in New York from Moscow on the first commercial flight between the two cities on July 15, 1968. The 13-hour-37-minute flight carried 93 passengers, 54 of them Soviet officials. Later that night, a Pan American Airways Boeing 707 departed on the first commercial New York to Moscow flight. (CAM.)

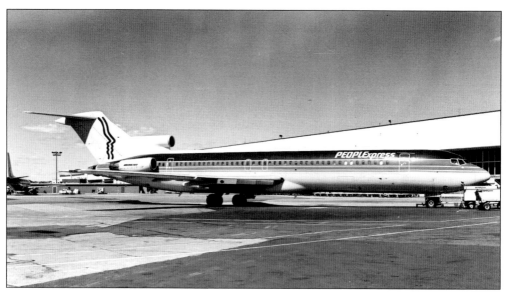

PEOPLE EXPRESS BOEING 727, 1982. The Boeing 727 was a three engine, narrow body, medium-range jetliner in production between 1963 and 1984. The best selling jet of its era, 1,832 were produced for airlines all over the world. Versatile and reliable, one of the main reasons for its success was its ability to carry a fair amount of passengers and still be able to use short runways. People Express (1981–1987) was the first American no-frills airline. With fixed low-cost ticket prices and no amenities, the airline was wildly successful at first but ultimately failed due to over-aggressive buying, heavy debt load, and increased competition. (CAM.)

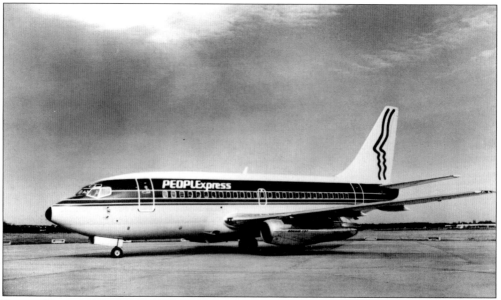

PEOPLE EXPRESS BOEING 737, 1983. The Boeing 737 is a narrow body medium-range airliner that first flew in 1967. In continuous production for over 40 years, it is the most-produced airliner in the world, with over 8,000 ordered to date. At any moment, 1,250 Boeing 737s are airborne. Currently the aircraft is in its ninth version (900 series) with larger wings, new, quiet fuel-efficient engines, and greater range. It can carry up to 215 passengers at 514 miles per hour, with a 3,000-mile range. (CAM.)

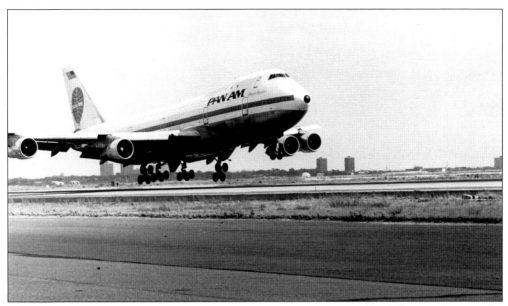

THE FIRST BOEING 747 TO ARRIVE AT JFK AIRPORT, 1970. Dubbed the "Jumbo Jet," the Boeing 747 was the world's first wide-body airliner. Two and half times the size of the Boeing 707, the 747 has been in continuous production since 1969. The iconic hump at the top of the fuselage allowed for a lounge area or additional first-class seating. The first commercial flight of the Boeing 747 occurred on January 22, 1970, when a Pan American World Airways Boeing 747 departed JFK for London. (PANYNJ.)

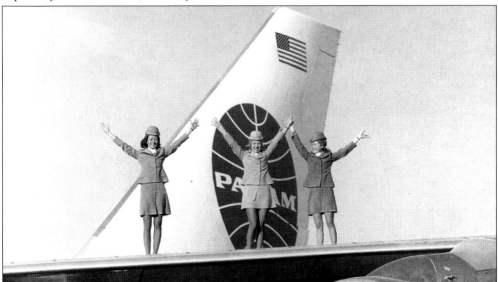

PROMOTIONAL PHOTOGRAPH FOR BOEING 747, 1970. Juan Trippe, president of Pan American World Airways, was largely responsible for pushing the development of the Boeing 747. Trippe believed that the congestion airports began to experience in the 1960s could be relieved through the development of aircraft twice as large as anything then flying. Instead, the larger aircraft led to the availability of more seats, reducing costs and prices, and leading many more people to fly. Here Pan American World Airways took various promotional photographs with the new Boeing 747 at JFK in order to get across to the public the sheer size of the new aircraft. (CAM.)

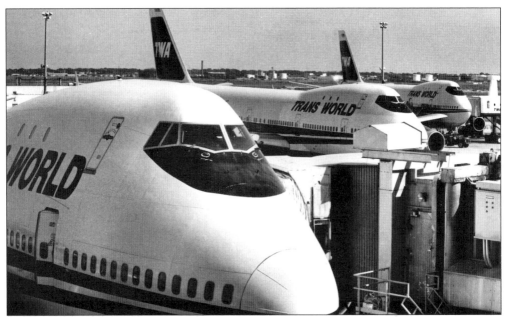

TWA Boeing 747s at JFK Airport, c. 1972. The first two airlines to purchase Boeing 747s were Pan American Airways and TWA. This is the first model of the Boeing 747 that was produced, the 100 series, as evidenced by the three windows on the upper deck. Aside from requiring new jetways, the Boeing 747's introduction into service went relatively smoothly. The aircraft has a wingspan of 200 feet and a length of 230 feet. (CAM.)

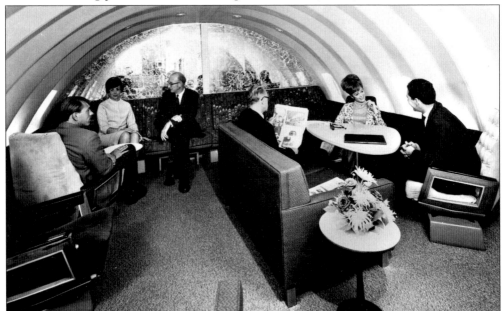

Upper Lounge of the Boeing 747, 1970. On the earliest versions of the Boeing 747, the upper deck was a lounge reserved for first-class passengers. However, airlines soon replaced this with additional first-class seating in order to have a bigger payload. This revised upper deck had 20 windows instead of the original three. The Boeing 747 can carry 416 passengers in three classes or up to 524 in two-class seating. (CAM.)

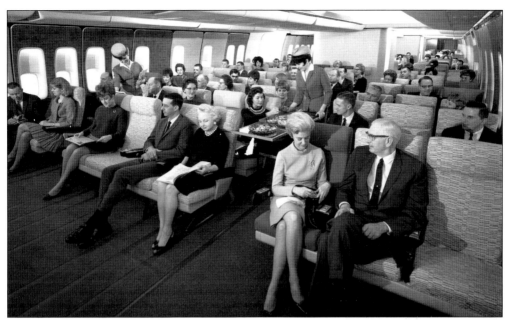

MAIN CABIN OF THE BOEING 747, 1970. The 20-foot-wide fuselage of the Boeing 747 allowed for 10-across seating plus two aisles. Later models of the Boeing 747 had stretched fuselages for greater passenger capacity plus new engines and avionics. Early models had a 5,000-mile range, but this has since been increased to over 8,000 miles in recent versions. One of the faster airliners, it cruises at 550 miles per hour, and over 1,400 have been built to date. (CAM.)

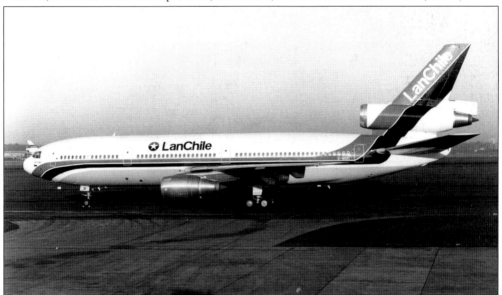

LAN CHILE MCDONNELL DOUGLAS DC-10 AT JFK AIRPORT, C. 1975. The DC-10 was a three engine wide-body airliner in production between 1969 and 1988. It was designed to have a long range like the Boeing 747 but still be able to use airports with shorter runways. First purchased by American Airlines, it was able to carry up to 380 passengers at 560 miles per hour with a 6,200-mile range. Although no longer in service as an airliner, it is still widely used as a freighter where its service has been far more successful. (CAM.)

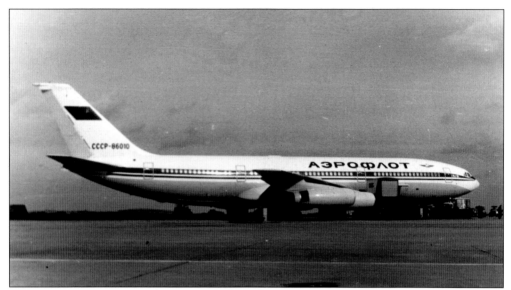

AEROFLOT IL-86 AT JFK AIRPORT, 1982. A four engine medium-range airliner, the IL-86 was Russia's first wide body jet. Equipped with obsolescent engines and having a prolonged development period, the IL-86 was in production between 1977 and 1994. Able to carry 350 passengers, the aircraft had a 1,900-mile range. Generally a safe and reliable aircraft, only 106 were built, as no one other than Aeroflot wanted to operate them. The IL-86 saw limited flights to New York, as unlike the Boeing 747, it required refueling stops at both Gander, Newfoundland, and Shannon, Ireland, in order to complete the Moscow-to-New York run. (CAM.)

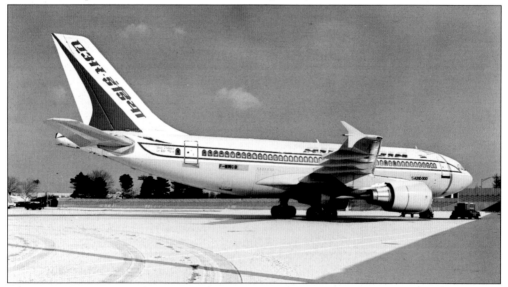

AIR INDIA AIRBUS A310 AT JFK AIRPORT, 1983. Founded in 1967, Airbus Industrie is a European aerospace consortium based in France and formed to compete with Boeing in the airliner market. Its first aircraft was the very successful Airbus A300, a 250 seat, twin aisle, twin-engine airliner. The Airbus A310, as seen here, was an improved version that was able to seat up to 275. It was in production between 1982 and 2007. Airbus has since come out with several new models of airliners, all of them successful, and it now produces about half of all the world's airliners. (CAM.)

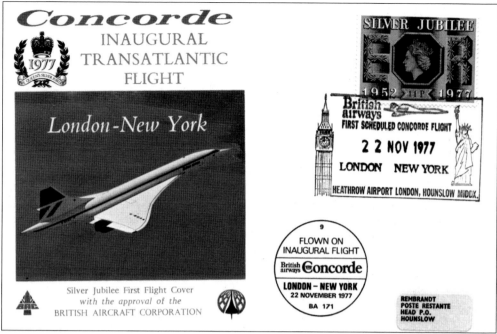

POSTAL COVER, FIRST CONCORDE FLIGHT TO NEW YORK, NOVEMBER 22, 1977. A joint British/French project, Concorde was developed by Aerospatiale/British Aircraft Corporation and is considered an icon of aviation history. As the world's only production supersonic transport, Concordes were built between 1969 and 1976 after a very costly development program. Due to their high cost and general lack of sales, only 20 were produced, and only Air France and British Airways operated them. The Concordes most successful routes were between New York and London and New York and Paris. After a protracted legal battle, Concorde service between New York and London was finally established in November 1977. (CAM.)

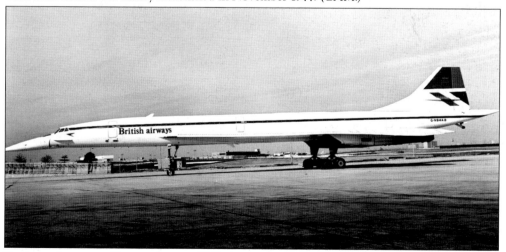

BRITISH AIRWAYS CONCORDE AT JFK AIRPORT, 1980. The Concorde was a supersonic narrow-body airliner only able to carry 100 passengers, all in first class. Its lack of space and amenities were made up for by the fact that it crossed the Atlantic Ocean in half the time of other airliners, or 3.5 hours versus seven. Unlike Air France, British Airways operated the Concorde service at a profit, although purchase costs were subsidized by the British government. (CAM.)

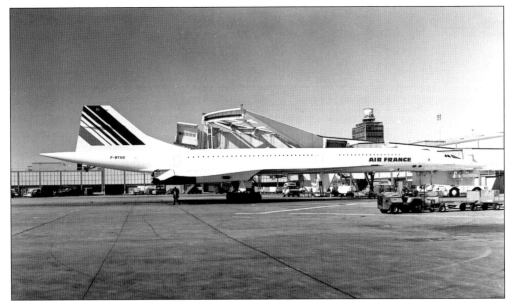

AIR FRANCE CONCORDE AT JFK AIRPORT, 1984. The Concorde crossed the ocean at record speed, Mach 2.2, more than twice the speed of sound. After beginning service between Paris and New York in 1977, Air France's last flight to JFK was on May 30, 2003. The last commercial Concorde flight to New York was made by British Airways on October 24, 2003. Due to aging aircraft, one fatal accident, and the high cost of operation, Concorde service was no longer economically viable. (CAM.)

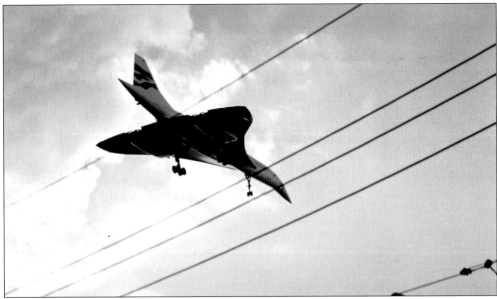

CONCORDE LANDING AT JFK AIRPORT, 2002. This is the view of the Concorde that residents around JFK airport will long remember. The port authority initially opposed Concorde flights to New York based on complaints over its noise made by local residents. Only after two years of legal battles were operations allowed to begin. Notice how the Concorde's nose was lowered on takeoff and landing in order to afford the pilots better visibility. It was raised into a streamlined position for supersonic operation. (Christopher Patti.)

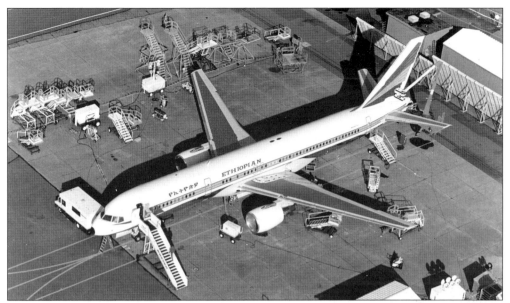

ETHIOPIAN AIRWAYS BOEING 767 AT JFK AIRPORT, C. 1985. The Boeing 767 is a mid-size twin-engine airliner first produced in 1982. It was designed to fit in size and range between the 727/737 and the 747. It was also designed with the range for nonstop transcontinental and transatlantic flights. Able to carry up to 375 passengers, the Boeing 767 sold well in the late 1980s and early 1990s and is still in production. Almost 1,000 have been sold to date, with another 1,000 on order. (CAM.)

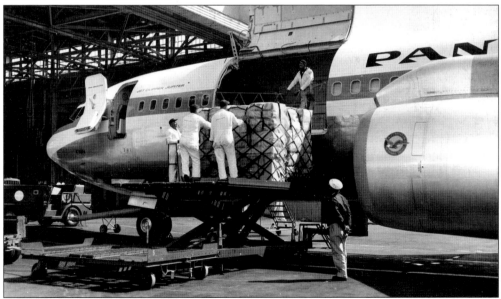

TWA BOEING 707 CARGO JET AT JFK AIRPORT, C. 1963. From its inception until today, JFK is America's busiest and largest international airfreight gateway. Over 20 percent of all U.S. international airfreight moves through JFK airport. The Boeing 707-320C freighter was a convertible passenger/freight aircraft. It featured a large door in the forward fuselage for freight and a significantly revised wing for better low-speed handling. With 335 built, it was the most-produced variant of the Boeing 707. (PANYNJ.)

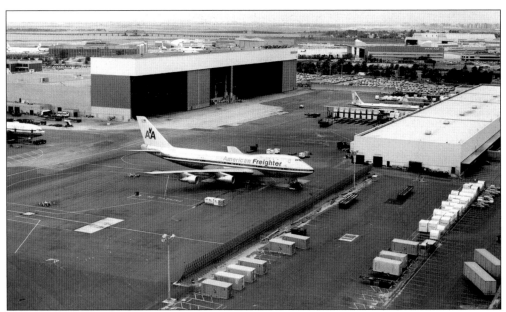

AMERICAN AIRLINES BOEING 747 FREIGHTER AT JFK AIRPORT, 1981. The 27 building, 350-acre cargo area at JFK airport is located on the north and west portions of the field. From its inception, Boeing planned on developing freighter versions of its 747. The highly successful Boeing 747-400F can carry up to 124 tons of cargo with a 4,500-mile range. This is a 100-series freighter that could only be loaded through a large fuselage side door. (PANYNJ.)

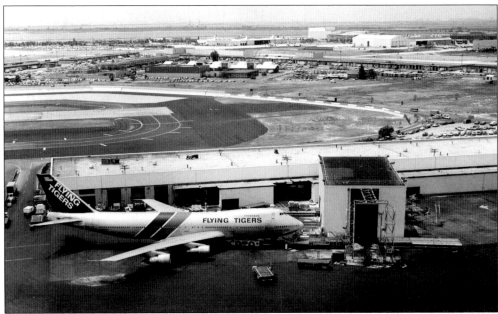

FLYING TIGERS 747 FREIGHTER AT JFK AIRPORT, 1981. Flying Tigers was the first-scheduled cargo airline in the United States. It was founded just after World War II by a former pilot in the famed Flying Tigers. By the mid-1980s, it was the largest airfreight carrier in the world after it purchased rival cargo carrier Seaboard World Airlines. In 1988, it was purchased by and absorbed into Federal Express. (PANYNJ.)

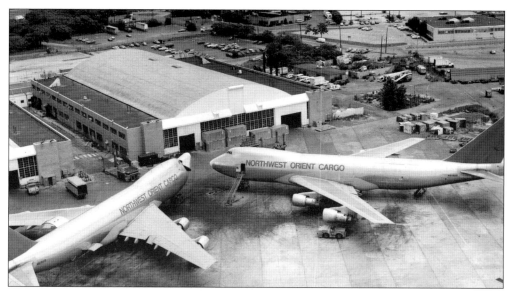

NORTHWEST ORIENT CARGO BOEING 747S AT JFK AIRPORT, 1981. Northwest Airlines, founded in the 1930s, expanded greatly into routes in the Far East after World War II. It then rebranded itself as Northwest Orient, but in the 1990s, it reverted to simply Northwest Airlines, or NWA. Northwest Cargo was the largest cargo carrier among combination U.S. passenger/cargo airlines. It had 15 dedicated Boeing 747 freighters that flew from key cities in the United States to points in Asia. In 2008, Northwest was purchased by Delta Airlines. These are Boeing 747-200F freighters, now with the more efficient front-loading doors. (PANYNJ.)

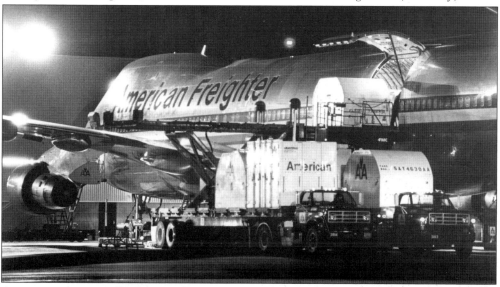

AMERICAN AIRLINES BOEING 747 FREIGHTER, C. 1983. JFK is a major hub for air cargo between the United States and Europe. London, Brussels, and Frankfurt are JFK's top three trade routes. Through the 1980s and 1990s, American Airlines operated nightly airfreight service between New York and Los Angeles. The aircraft were able to carry over 100 tons of cargo loaded either through its large front or side doors. Boeing 747 freighters also have the ability to carry oversize loads, as front loading optimizes the plane's ability to carry the maximum amount of cargo. (CAM.)

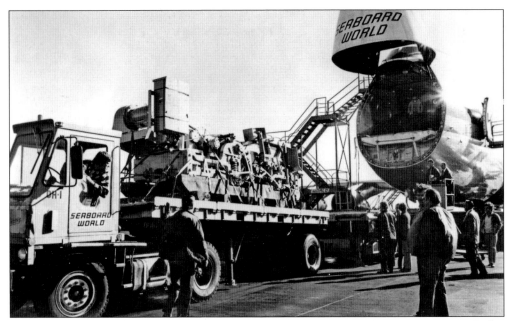

SEABOARD WORLD AIRLINES BOEING 747-200F FREIGHTER AT JFK AIRPORT, C. 1980. Today Boeing 747s comprise three quarters of the world's wide body freighter fleet. Nearly 100 cargo air carriers now operate out of JFK, with American Airlines being the largest. Some of the cargo imported and exported through JFK include machinery, clothing, medical equipment, shoes, plastics, and paper. (Seaboard World Airlines.)

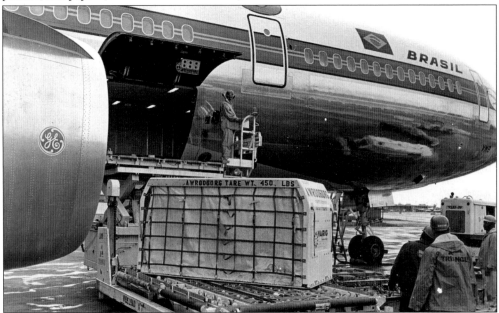

DC-10 FREIGHTER AT JFK AIRPORT, C. 1980. In the 1970s, the DC-10CF was produced as a convertible passenger/cargo aircraft. Freight could be placed on two levels, with 30 containers on the main level and an additional 15 in the lower hold, as seen here. Featuring 16,000 cubic feet of cargo space, 35 DC-10 freighters were produced, and most are still in daily use. The DC-10 saw a far longer useful life as a freighter than as a passenger aircraft. (PANYNJ.)

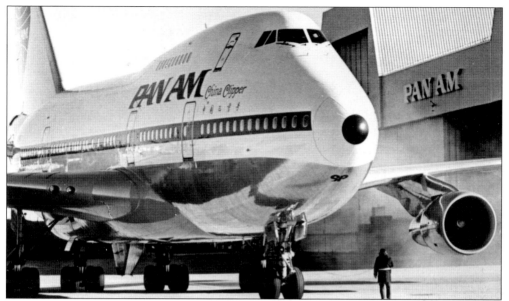

PAN AMERICAN AIRWAYS BOEING 747 *CHINA CLIPPER* IN FRONT OF HANGAR 19, C. 1980. In 1971, Pan American Airways constructed a unique maintenance facility at JFK–Hangar 19. Designed specifically to handle the maintenance of Boeing 747s, the huge complex was located in the northwest corner of the airport next to the beginning of runway 13R. Known as the Pan Am Jet Center, this was the only major overhaul base located at JFK airport. Built at a cost of $57 million, the Jet Center is the size of 11 football fields. (PANYNJ.)

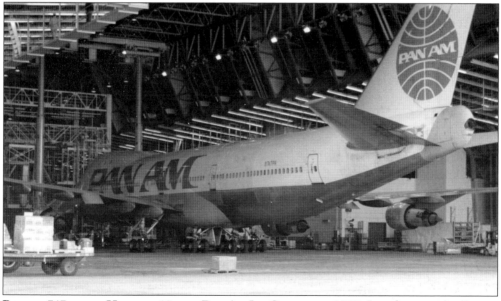

BOEING 747 INSIDE HANGAR 19, THE PAN AM JET CENTER, C. 1980. In order to service Boeing 747s, Pan American Airways designed huge mobile maintenance stands. Upon Pan American Airway's demise, there were no longer any major maintenance operations at JFK. Still the largest hangar complex at the airport, Hangar 19 is sometimes used to handle Air Force One or other unique movements. The facility is now largely used to handle air cargo and is the headquarters for Polar Air's cargo and maintenance operations. (Paul Steidel.)

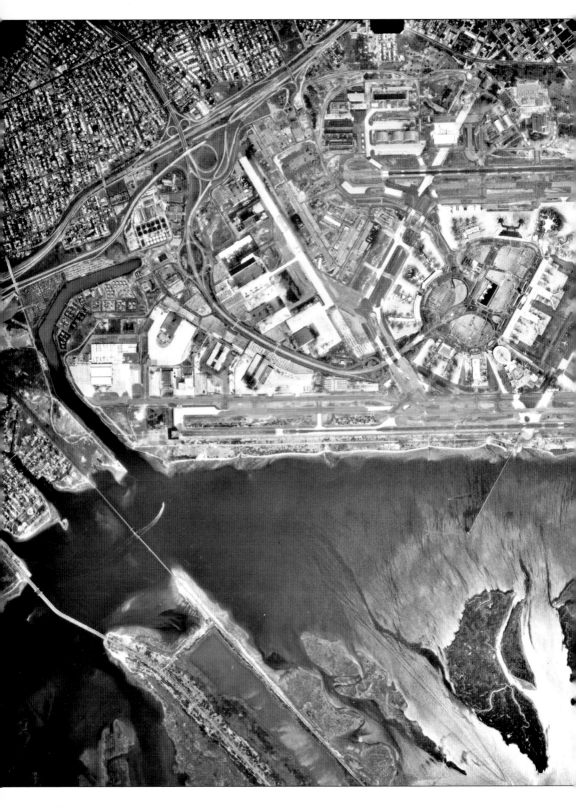

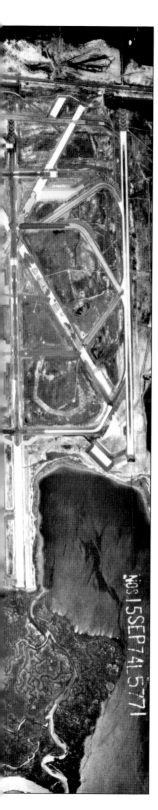

JFK Airport, Aerial View, c. 1980. Viewed from directly overhead, the entire layout of the airport can be seen. There are two pairs of parallel runways left, although disused runways now used as taxiways, can be seen. The south is bordered by Jamaica Bay, and the Belt Parkway borders the north. In the center is the sprawling terminal complex. Runway 13R-31L is the second-longest commercial runway in the world at 14,572 feet. Other runways range between 8,000 and 10,000 feet. JFK has over 25 miles of taxiways to move aircraft in and around the field. The airport is now one-third the size of Manhattan Island. (CAM.)

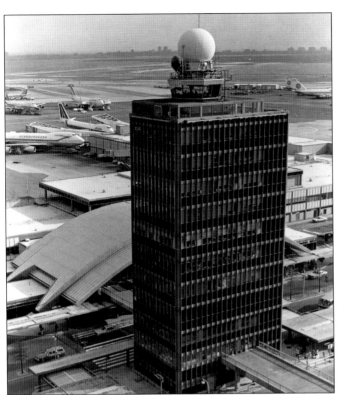

JFK Airport Control Tower and Flightline, 1980. In a scene that was first entirely dominated by Lockheed Constellations, controllers at JFK now looked out on nothing but Boeing 747s. By the mid-1980s, JFK was again experiencing extreme pressure due to the steadily increasing air traffic. Plans were formed, once again, for the redevelopment of the airport. Although barely 30 years old, the control tower, International Arrivals Building, and virtually every terminal on the field was about to undergo a complete reconstruction from the ground up. (PANYNJ.)

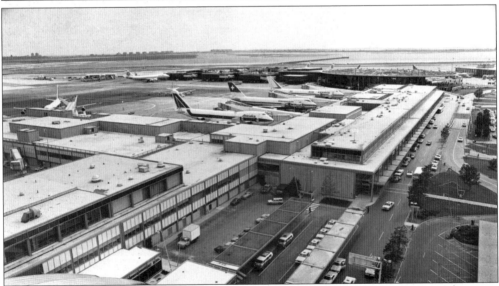

JFK Airport, West Airline Wing, c. 1980. The west wing, now crowded with 747s, has long since been equipped with jetways. In the distance can be seen the Pan American Worldport with Jamaica Bay beyond. By 1988, 16.7 million people flew out of JFK headed for non-U.S. destinations. Due to this overwhelming surge, by the late 1980s, the redevelopment of the airport was set to begin. In the first phase, a new roadway system was developed that allowed access to the four quadrants into which the central terminal area was divided. The next step was the construction of a new 30-story control tower. (PANYNJ.)

Five

JFK TODAY
1991–2009

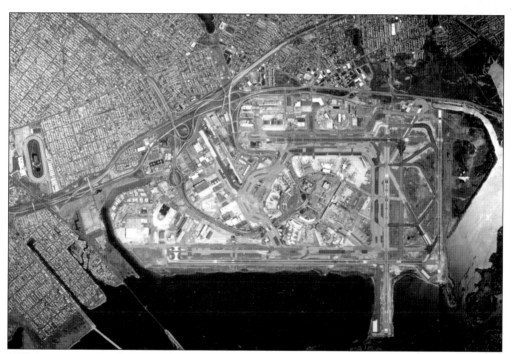

JFK AIRPORT, 1990. In spite of consistently increasing air traffic, the lack of room for expansion is obvious. The airport's tank farm is visible on Bergen Basin, the canal on the left side of the field. The Van Wyck Expressway, constructed specifically to speed airport traffic, aims toward the upper-left corner. In order to develop a far more efficient airport, the port authority committed to spend over $5 billion between 1990 and 2005 on new construction. This was not an expansion or modification of the existing airport; it was literally building an entirely new $10 billion airport from the ground up. (CAM.)

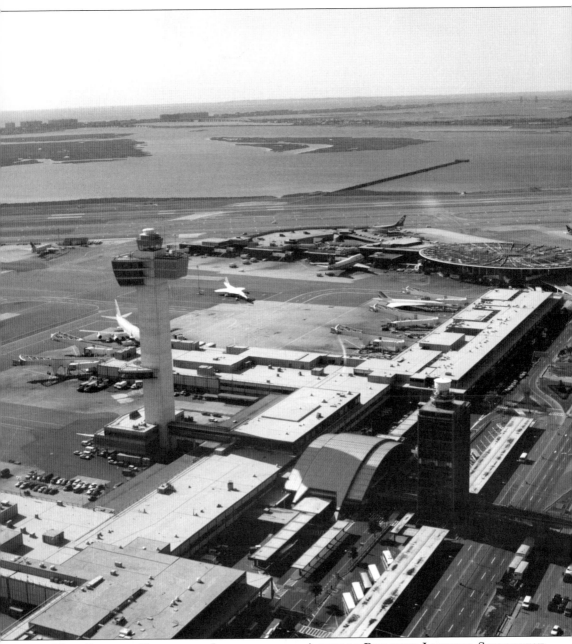

New Control Tower and International Arrivals Building Looking Southwest, 1991. The first step in airport redevelopment was the construction of a new control tower. Here still under construction is the new tower on the left, with the old tower still in operation on the right. At 321 feet, this was now the tallest control tower in the United States. Located on the ramp side of the old International Arrivals Building, the new tower became fully operational in 1992. The old International Arrivals Building was about to be demolished and replaced with the $1.2 billion, 17-gate international air terminal, or Terminal 4. JFK's outbound international travel accounted for 17 percent of all U.S. travelers going overseas. It now handles an average of about 50,000 international travelers each day. Note two Concordes on the flightline. (CAM.)

THE NEW TOWER, 1994. This new tower, much taller than the old one, provides controllers with an unobstructed view of the entire field and is equipped with state-of-the-art radar, wind shear, and other equipment. An Airport Surface Detection Equipment (ASDE) radar unit sits atop the tower. Working controllers only occupy the very small top portion of the tower; lower floors are taken up by a Federal Aviation Administration office and lounge areas. In front of the tower sits a Viasa Airbus A300. (CAM.)

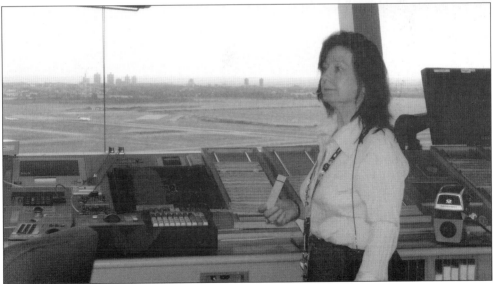

TOWER INTERIOR, 2008. The JFK airport tower has the most-advanced air traffic control equipment in the United States. In 2001, it was upgraded with Terminal Doppler Weather Radar Wind Shear equipment. Enthusiastic tower controllers have also set up a Web site (JFKTower.com) so the public can listen in on live air-traffic control transmissions and get other airport information. Here is air-traffic controller Susan Rose at work. One piece of original equipment from the 1948 tower has found its way into the new tower—the original light gun still hangs from the ceiling. (Tyler Stoff.)

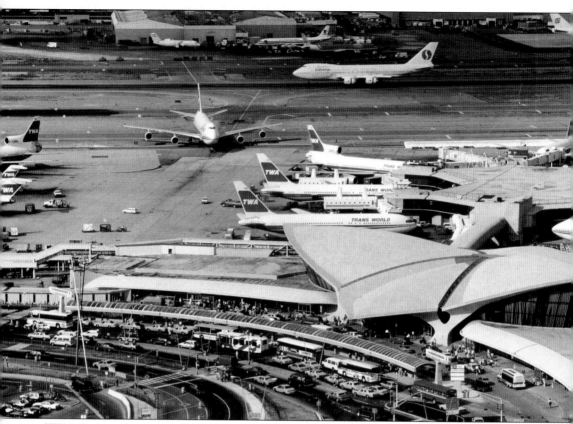

TWA FLIGHT CENTER, 1994. TWA was founded in 1930, and until it was acquired by American Airlines in 2001, it was one of the largest domestic U.S. airlines. Beyond the United States, TWA had a highly developed European and Middle East network served from this hub at JFK. In 1967, TWA became the first American all-jet airline with the retirement of its last Lockheed Constellation. This terminal stood empty from TWA's demise in 2001 until it was acquired by JetjBlue Airways in 2005. The original historic terminal has since been linked to a massive new structure. (CAM.)

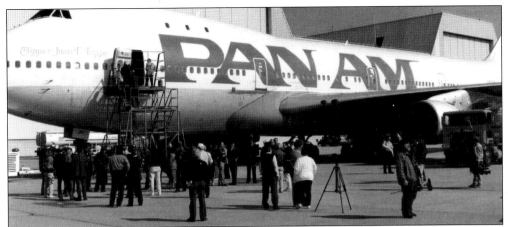

LAST PAN AMERICAN AIRWAYS FLIGHT FROM JFK, MAY 15, 1992. Pan American Airways was the principal international airline of the United States from its founding until its collapse in December 1991. It is credited with many innovations that shaped the international airline industry, including the first widespread use of jet aircraft, the first jumbo jets, and the first computerized reservation systems. At its peak, it was providing scheduled service to every continent except Antarctica. The company's demise was caused by several factors, including rising fuel costs, heavy investment in wide bodies, corporate mismanagement such as the purchase of several smaller airlines, and international terrorism. Pan American Airways ceased commercial operation in December 1991 and sold off all its assets (the terminal went to Delta Air Lines). Seen is its last-remaining aircraft that was at JFK undergoing maintenance in Hangar 19. (Paul Steidel.)

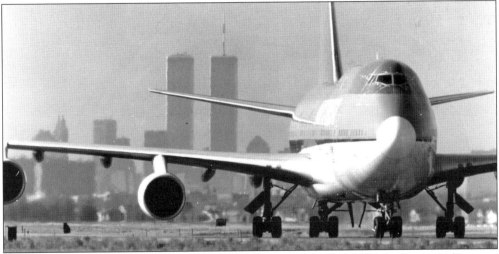

NORTHWEST AIRLINES BOEING 747 AT JFK AIRPORT, 1984. In 2008, Northwest Airlines was the world's sixth-largest airline in terms of domestic and international passenger miles flown. It had one of the largest domestic networks, and it moved more domestic air cargo than any other U.S. passenger line. It was also one of only two passenger airlines in the United States to operate the long range Boeing 747-400 (the other was Delta Air Lines). This Boeing 747, in a foreshortened view, is sitting on the end of runway 13R. It is actually a lot farther than it seems from the former World Trade Center. The end of the runway is actually about 15 miles distant, with all of Brooklyn in between. In late 2008, Northwest Airlines merged with Delta Air Lines to create the world's largest airline. (PANYNJ.)

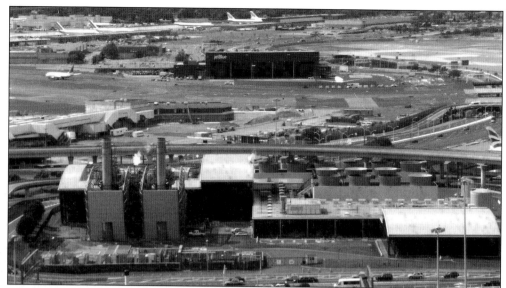

JFK Airport Cogeneration Plant Looking Northwest, 2008. As part of the ongoing $10 billion redevelopment of the airport begun in 1990, JFK now has its own state-of-the-art power plant. Previously, the central plant just produced hot and cold water for heating and air-conditioning. It now has this gas-fired electric cogeneration plant that generates all the electricity for the airport, with an output of about 90 megawatts. It also uses thermal energy from the capture of waste heat to heat and cool all the passenger terminals and other facilities in the central terminal area. (Tyler Stoff.)

Kalitta Air Boeing 747 at JFK Airport, 2008. As the terminal area of the airport was totally redeveloped through the 1980s, so were the airport's cargo areas. Four new cargo centers, ranging in cost up to $100 million, were built on the airport's north and west sides by Japan Airlines, Korean Air, United Airlines, and Northwest Airlines. Almost inconspicuously, from the passengers' viewpoint, some two million tons of cargo, worth over $100 billion, passes through JFK each year. Kalitta Air is a Michigan-based worldwide airfreight carrier operating 14 Boeing 747 freighters, all purchased used. It handles airfreight, scheduled or on-demand, worldwide, as well as operations for the Department of Defense. (Tyler Stoff.)

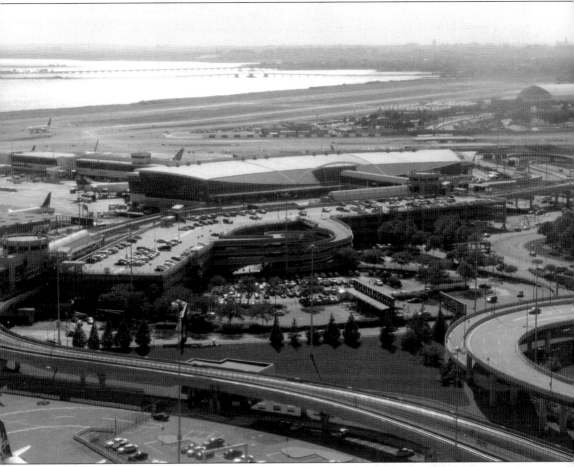

TERMINAL 1 LOOKING WEST, 2008. The original Terminal 1, built as a hub for Eastern Air Lines, was demolished, and a new $435 million terminal with 11 gates was opened in 1998. Terminal 1, designed by William Bodouva and Associates, was developed by a consortium of four foreign carriers: Air France, Japan Airlines, Korean Air, and Lufthansa. The terminal has 635,000 square feet of space. The check-in hall has four islands for use by each of the airlines. Beyond that is a two-level rotunda used as a food court. There is room in the terminal for approximately seven more airlines. All the new terminals at JFK adhere to an esthetic that replaced the wide variety of styles of the original terminals. The new style, referred to as airfoil modern, is characterized by glass and steel buildings with rooflines gently bowed like the top of an airplane's wing and smooth silver surfaces resembling its skin. (Tyler Stoff.)

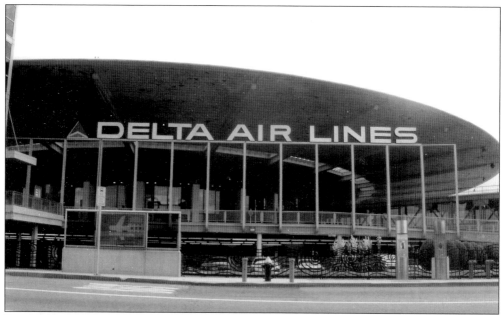

DELTA AIR LINES'S TERMINAL 3, 2008. Terminal 3, with 17 gates, was originally built as the Pan American Worldport in 1960 and was substantially expanded for the introduction of the Boeing 747 in 1970. Delta Air Lines currently uses the entire terminal and has a connection to Terminal 2, its other terminal at JFK. Delta Air Lines has undertaken the refurbishment of Terminals 2 and 3 for its hub operation. (Tyler Stoff.)

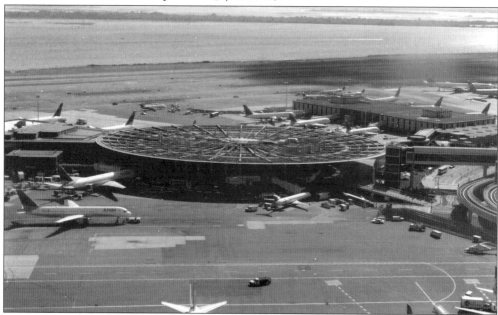

TERMINALS 2 AND 3, LOOKING SOUTHWEST, 2008. The elliptical Terminal 3 sits in the center with Terminal 2 just beyond. Terminal 2 was opened in 1962 as the home of Northeast Airlines, Braniff, and Northwest Airlines. After the demise of Northeast Airlines and Braniff, the building was taken over by Delta Air Lines. The terminal has 11 gates. Delta Air Lines still plans on merging its two terminals at JFK into a single, modern terminal in the future. (Tyler Stoff.)

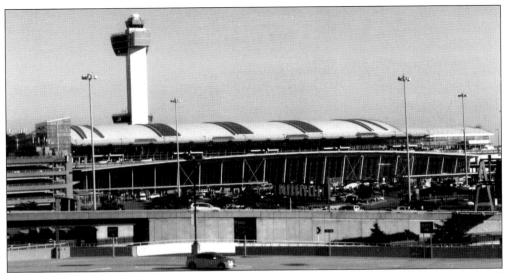

TERMINAL 4, 2008. Terminal 4, the new international terminal that replaced the International Arrivals Building, is currently the only terminal at JFK able to handle the Airbus A380. It is managed by Schipol USA, a subsidiary of the Dutch company that runs Schipol, the Amsterdam Airport. It was the first airport terminal in the United States to be managed by a foreign airport operator. Terminal 4 is now the major gateway for international arrivals at JFK. Opened in 2001, the new 1.5 million-square-foot building was constructed at a cost of $1.4 billion. The terminal has 17 gates on two concourses, although it can be expanded incrementally to have as many as 37 gates. (Tyler Stoff.)

INTERIOR OF TERMINAL 4, 2008. As Terminal 4 was built during the construction of JFK's AirTrain, the AirTrain station was actually placed inside the terminal building. Other AirTrain stations are built across from terminal buildings. Terminal 4's expansive 1,000-foot-long shopping mall with several food courts offers a wide range of retail options before security, so passengers and their families can enjoy shopping and dining together. This terminal alone is currently serviced by 46 airlines. (Tyler Stoff.)

OUR LADY OF THE SKIES CHAPEL, TERMINAL 4, 2008. The main hall of the terminal incorporates design elements like a clock tower and topiary intended to conjure up the neighborhoods and landmarks of New York City. Due to a lack of space, however, JFK no longer has striking freestanding chapels. Several chapels, including this third incarnation of Our Lady of the Skies Chapel, were incorporated on the east end of the mezzanine level. (Tyler Stoff.)

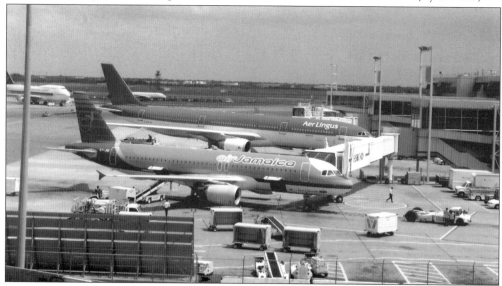

FLIGHTLINE ON THE EAST END OF TERMINAL 4, 2008. Today nearly 100 airlines from over 50 countries operate regularly scheduled flights from JFK, and the flightline is an ever-changing sea of colorful airliners. The Air Jamaica Airbus A310 in front is a 187-passenger shorter, re-engined version of the Airbus A300 in production between 1982 and 2007. Behind is an Aer Lingus Airbus A330, a large-capacity, long range, twin-engine airliner. First delivered in 1998 (Aer Lingus of Ireland was one of the first customers), the aircraft is capable of carrying up to 420 passengers. (Tyler Stoff.)

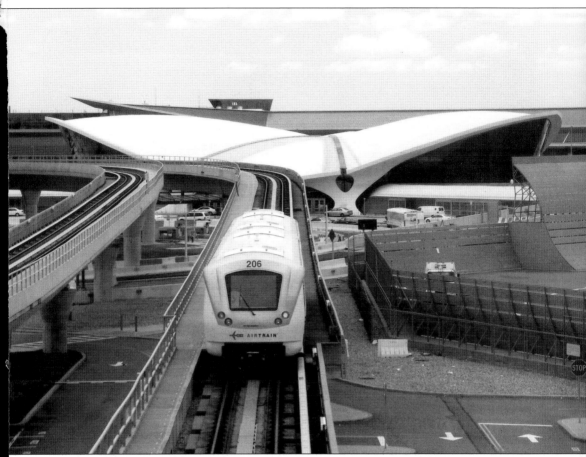

AIRTRAIN JFK AND TERMINAL 5, 2008. The AirTrain JFK is an 8.1-mile elevated people-mover system that connects the airport to New York City's subway and commuter trains. It opened in 2003 and is operated by Bombardier Transportation under contract to the port authority. AirTrain stops at all terminals, car rental lots, and two subway stations. It is free within the airport and $5 to reach the subway and Jamaica station. Using this system, travel time between JFK and midtown Manhattan has been cut to 30 minutes. (Tyler Stoff.)

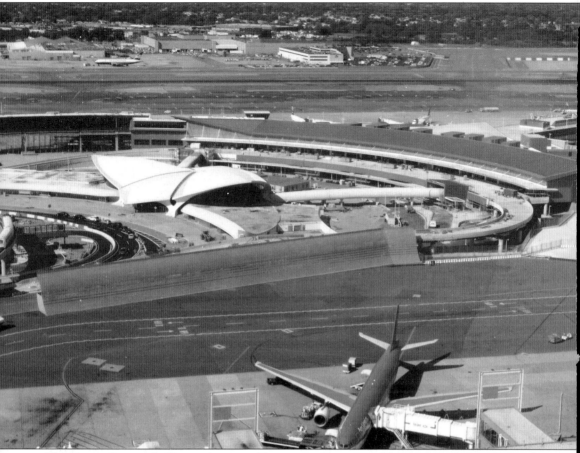

TERMINAL 5, THE JETBLUE AIRWAYS TERMINAL, LOOKING NORTHEAST, 2008. Recently completed is the spectacular new JetBlue Airways Terminal 5, which incorporates the historic landmark TWA Flight Center. The original TWA terminal now sits in the complex's center with the huge new arc of Terminal 5 behind it. The $875 million terminal, completed in the fall of 2008, supports 500 daily departures and arrivals. The new 26-gate terminal is the largest construction project of any unit terminal since the airport's inception. While this was under construction, JetBlue Airways temporarily used Terminal 6, the former National Airlines terminal, but there are no plans for its future use. (Tyler Stoff.)

TERMINAL 7, THE BRITISH AIRWAYS AND UNITED AIRLINES TERMINAL, 2008. Terminal 7 was originally built for BOAC and Air Canada in the early 1970s. In 1997, the port authority entered an agreement with British Airways to expand the terminal. The renovated terminal has 12 gates. British Airways is now investing an additional $100 million in a new Terminal 7 renovation, and the port authority is spending a further $43 million on related roadway work. Key features will be expanded check-in and retail areas, a new theatrical lighting system, new lounges, and new parking decks. (Tyler Stoff.)

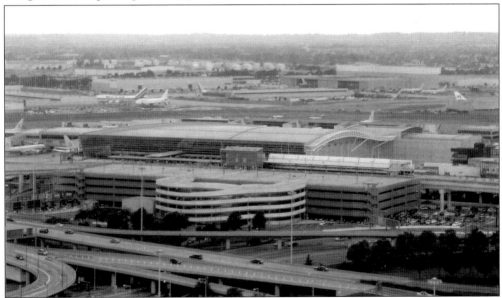

TERMINAL 8, THE AMERICAN AIRLINES TERMINAL, 2008. In 1999, American Airlines began an eight-year program to build the largest passenger terminal at JFK. The project is a $1.3 billion venture that required the demolition of the old Terminals 8 and 9 and their replacement with a mega-terminal, featuring 56 gates, with 37 for large jets and 18 for American Eagle's regional jets. Designed to accommodate more than 13 million passengers annually, the terminal officially opened in August 2007, despite having already been handling flights for almost two years. (Tyler Stoff.)

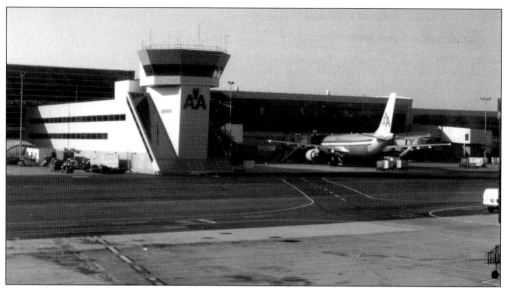

GROUND CONTROL TOWER AT THE AMERICAN AIRLINES TERMINAL, 2008. The new American Airlines complex also includes a customs and immigration facility that can serve up to 2,400 people an hour, a 53,000-square-foot retail and concession space, and a new parking garage. The complex was constructed in four stages to allow for uninterrupted passenger service. The 2.2 million-square-foot terminal is by far the largest unit terminal at JFK. In 2008, the old Terminal 8 was demolished to make way for the remainder of the new one to be built. This included the dismantling of its iconic 300 foot long stained-glass wall. (Tyler Stoff.)

INTERIOR OF THE AMERICAN AIRLINES TERMINAL, 2008. The terminal, about 50 percent larger than Madison Square Garden, offers dozens of retail and food outlets, 84 ticket counters, 44 self-service kiosks, and 10 security lanes. There are three primary levels on four concourses, including one for arrivals, one for departures, and one for clubs, lounges, and offices. The 200 interior positions are arranged in four check-in islands and two rows of counters along the sides of the main lobby, as seen here. (Tyler Stoff.)

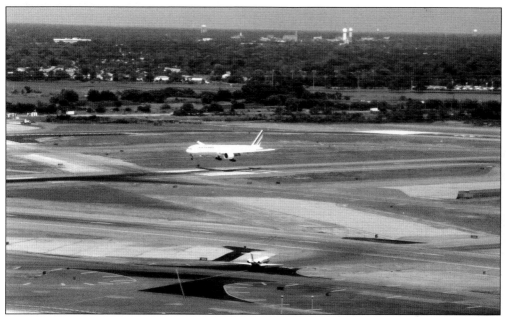

JFK Airport Looking Northeast, 2008. This Air France Boeing 777 is landing on runway 31R. The Boeing 777 is a long range wide-body airliner that is the world's largest twin-engine jet. It can carry up to 368 passengers and has a range of 4,400 miles. The runways at JFK have recently been resurfaced with an environmentally friendly concrete system called Econocrete. Runway 13L-31R is the airport's second-shortest runway at 10,000 feet. (Tyler Stoff.)

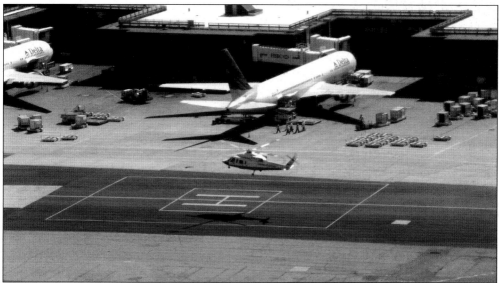

U.S. Helicopter Sikorsky S76 Landing at JFK. JFK airport was served by New York Airways helicopter shuttle service from Manhattan between 1949 and 1979. It is currently served by U.S. Helicopter, founded in 2006. Operating Sikorsky S76s, with first-class executive interiors, the helicopters fly between the downtown Manhattan heliport and Terminal 3 every 30 minutes. Passengers traveling by helicopter pass through a security checkpoint at the heliport rather than at JFK. The flights last only eight minutes and cost $159 each way. These eight-seat helicopters are the only scheduled helicopter service in the United States today. (Tyler Stoff.)

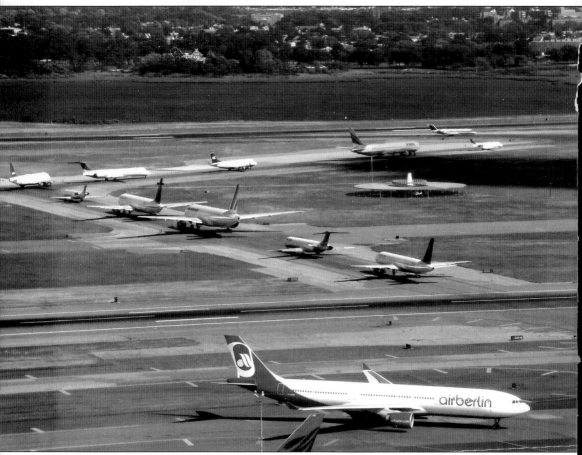

AIR TRAFFIC AT JFK AIRPORT, 2008. One of the world's busiest airports, JFK now handles almost 50 million passengers annually. Airliners from 100 airlines and 50 countries can be seen at the airport on a daily basis. These airliners, on a rather busy afternoon, wait to take off on runway 31L. Runway 13R-31L is the second-longest commercial runway in the world at almost 15,000 feet. The large circular structure between the taxiways is a VOR (VHF Omni-directional Radio Range) station, a navigational beacon. (Tyler Stoff.)

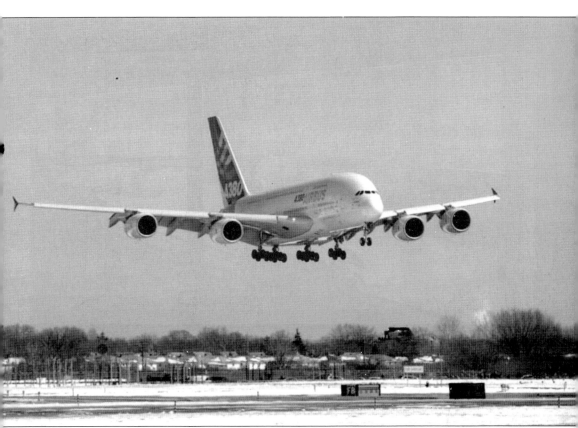

AIRBUS A380 LANDING AT JFK AIRPORT, 2007. History was made on March 19, 2007, when JFK became the first airport in the United States to receive the Airbus A380. The route-proving flight, with more than 500 passengers on board, was operated jointly by Lufthansa and Airbus and arrived at Terminal 1. The Airbus A380 is a double deck wide-body airliner that first flew in 2005. This is the largest passenger airliner in the world with 50 percent more floor space than the Boeing 747. It can carry up to 853 people, with an 8,200-mile range. On August 1, 2008, the first commercial flight of the aircraft was made to JFK when an Emirates Airbus A380 arrived from Dubai after a 13-hour-43-minute flight. Thus JFK airport has witnessed the steady progress of commercial aviation for 60 years and certainly will for many decades to come. (PANYNJ.)

ACROSS AMERICA, PEOPLE ARE DISCOVERING
SOMETHING WONDERFUL. *THEIR HERITAGE.*

Arcadia Publishing is the leading local history publisher in the United States.
With more than 3,000 titles in print and hundreds of new titles released every
year, Arcadia has extensive specialized experience chronicling the history of
communities and celebrating America's hidden stories, bringing to life the people,
places, and events from the past. To discover the history of other communities
across the nation, please visit:

www.arcadiapublishing.com

Customized search tools allow you to find regional history books about the town
where you grew up, the cities where your friends and family live, the town where
your parents met, or even that retirement spot you've been dreaming about.